Fairies, Mermaids, & Other Mystical Creatures

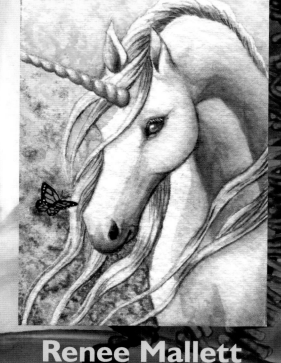

Renee Mallett

Schiffer Publishing Ltd

4880 Lower Valley Road, Atglen, Pennsylvania 19310 USA

Other Schiffer Books by Renee Mallett
Manchester Ghosts, 978-0-7643-2650-9, $14.95

Other Schiffer Books on Related Subjects
Schiffer Publishing, Ltd. has a wide selection of books about ghosts and the supernatural. Please visit their website for more information.

Copyright © 2008 by Renee Mallett
Library of Congress Control Number: 2007936694

Designed by Ellen J. (Sue) Taltoan
Type set in Humanst521 BT
ISBN: 978-0-7643-2803-9
Printed in China

Schiffer Books are available at special discounts for bulk purchases for sales promotions or premiums. Special editions, including personalized covers, corporate imprints, and excerpts can be created in large quantities for special needs. For more information contact the publisher.

Published by Schiffer Publishing Ltd.
4880 Lower Valley Road
Atglen, PA 19310
Phone: (610) 593-1777; Fax: (610) 593-2002
E-mail: Info@schifferbooks.com

For the largest selection of fine reference books on this and related subjects, please visit our web site at:
www.schifferbooks.com
We are always looking for people to write books on new and related subjects. If you have an idea for a book please contact us at the above address.

This book may be purchased from the publisher.
Include $3.95 for shipping.
Please try your bookstore first.
You may write for a free catalog.

In Europe, Schiffer books are distributed by
Bushwood Books
6 Marksbury Ave.
Kew Gardens
Surrey TW9 4JF England
Phone: 44 (0) 20 8392-8585; Fax: 44 (0) 20 8392-9876
E-mail: info@bushwoodbooks.co.uk
Website: www.bushwoodbooks.co.uk
Free postage in the U.K., Europe; air mail at cost.

Contents

Dedication

This book is dedicated to Catherine Cassady, Nancy Chant, and Ronald Tersigni. Teachers

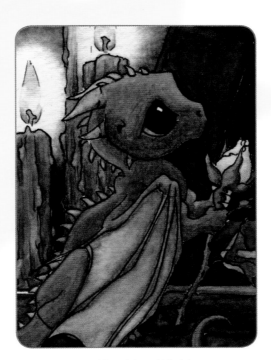

Thank You. *By Misti Hope Wudtke.*

Myth, Folklore, & Legend

> "I believe in everything until it's disproved. So I believe in fairies, the myths, dragons. It all exists, even if it's in your mind. Who's to say that dreams and nightmares aren't as real as here and now?"
>
> *John Lennon*

Creatures of Myth

The mythological aspect of this book probably needs no introduction. My fascination with folklore, fairytales, and myth is certainly nothing unique. Archaeologists have said that if you know how a society treats their dead, then you know everything you need to know about them, but I would make the case that the second most telling thing is the stories people tell amongst themselves. These stories, passed down through the ages, were used as ways for people to explain the world around them, to pass the time, and to delight each other—long before the advent of the canned entertainment our society thinks we just couldn't live without.

What is most fascinating is how many of the same elements of these stories pop up in all different time periods, from all around the world. We may think of dragons as being a very Asian creature, or think of them as terrorizing the woods around a medieval European village, but the Native Americans told tales of dragons as well. Almost all cultures have stories of dragons ... or at least creatures similar enough that we would define them as dragons. The same holds true for almost all the fantasy creatures you can name—elves, fairies, mermaids, dwarves, and others. The very same creatures that interest us today interested our ancestors. There's a reason why these creatures and these stories have survived the tests of time. Their ability to fascinate through the ages is a type of magic all in itself. And sometimes the evolution of the stories from the olden days to the more modern present day is as interesting as the stories themselves.

Modern Mythology?

One of the terms you'll find in this book that you may not be familiar with is the idea of 'modern mythology'. Most people think of mythology as the stories of past religions or cultures, things that use to matter but that are now used as bedtime stories and fairytales for children. But we are right now, today, adding to mythology and evolving some of the myths.

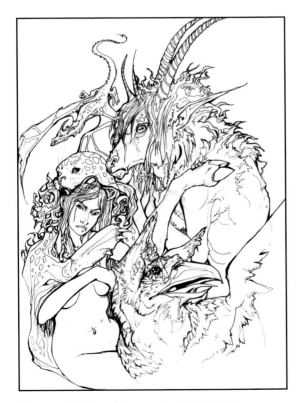

Group of Mythical Beasts. *By Molly Zirofax Rodman.*

The popularity of the fantasy genre is undeniable. Look at the high grossing blockbuster films—the Star Wars franchise, for instance. Or the availability of the Amy Brown fairy merchandise lining the shelves of every place, from stationary stores to teenage havens like Hot Topic. As far as books go, less than two percent of the books published are fantasy novels, but that two percent garners nearly ten percent of the sales market. Blame it on Harry Potter if you must, but fantasy novels, for both kids and adults, sell more copies than almost any other genre. Only the business, self help, religious, and romance fiction markets take a larger percentage of sales. Fantasy novels outsell travel books and how-to books combined. They even beat out mystery and thrillers sales!

When we talk about modern myths we're talking about our new take on classic ideas. Video games, like the popular Final Fantasy series, role-playing games, like Dungeons and Dragons, and collectible card games, like Magic: the Gathering, all contribute to what we think of when we say the word fairy, or dragon, or elemental. Our modern mental images usually stem from, but differ wildly, from the earlier meaning of these words.

Of course, almost all the 'new' ideas in modern mythology can be traced back to the father of the modern fantasy novel, J.R.R Tolkien. Tolkien, a devout Roman Catholic, enjoyed making up fantasy stories for his children. At the urging of his dear friend and fellow writer, C.S Lewis, Tolkien tried his hand at publishing one of these impromptu bedtime stories. He named it *The Hobbit*. It ended up attracting as many adult readers as children, and was so popular his publisher asked him to write a sequel. Tolkien would, at this urging, create the immensely popular *The Lord of the Rings* trilogy. Those books, however, took a much darker and adult turn than *The Hobbit*, pulling Tolkien firmly out of children's writing and into fantasy writing forever. Until his death in 1973, Tolkien continued to write fantasy stories set in the mythical Middle Earth that was home to both *The Hobbit* and *The Lord of the Rings*. His youngest son, Christopher, has continued on the family tradition and, working from his father's notes, written his own Middle Earth tales.

The Lord of the Rings is one of the most popular books of the twentieth century, based on sales and a plethora of reader surveys. Both the United Kingdom and Australia have named it the "Nation's Best Loved Book." An Amazon.com reader survey has dubbed it the "Book of the Millennium." It can be argued that no other single source has done as much to influence modern mythology than the works of J.R.R Tolkien.

Tolkien invented many of his mythic races, or added new facets and personalities to little known existing ones. While his work does not stay entirely true to historical mythology, many of his ideas stem from already existing ones. Because of Tolkien's works we most commonly use the word 'dwarves' rather than 'dwarfs', which was the accepted spelling until his books were released. Tolkien didn't make up the word, or its spelling—it had been an archaic form of the spelling that had fallen out of use at least a hundred years before. The same is true for 'elvish' rather than 'elfish'.

We continue to feel the influence of Tolkien's stories even today. In 2001 director Peter Jackson released his cinematic adaptation of the first *Lord of the Rings* novel, *The Fellowship of the Ring*. The movie won an Academy Award and, at $870 million, was the second highest grossing movie of 2001. It was only narrowly beat out by another movie adaptation of a fantasy novel, *Harry Potter and the Philosopher's Stone*.

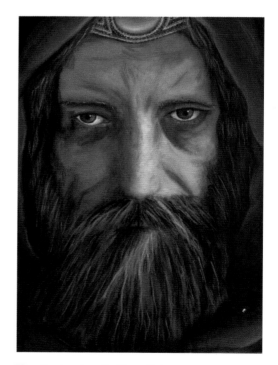

The Enchanter. *By Tiana Fair.*

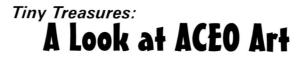

Tiny Treasures:
A Look at ACEO Art

"The history of art is the history of revivals."
Samuel Butler

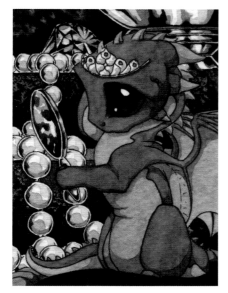

Lily. *By Misti Hope Wudtke.*

Frog Wings. *By Christi Brown.*

What is ACEO?

Even though the mythological side of this volume needs no explanation, the art shown might. All of the artwork shown in *Fairies, Mermaids, and Other Mystical Creatures* is ACEO art, and like the creatures and stories in this book, the artists come from all around the world.

ACEO stands for 'Art Card, Edition and Original', sometimes this type of art is called art trading cards (though art trading card purists take offense at this since art trading cards can only be traded between artists and never sold to the general public as ACEO's are), or they can be called simply art cards, or OOAK ('one of a kind'). An ACEO is any genre of art, in any medium, on any subject you can imagine, but it is the size of a standard baseball card, or roughly 2.5" by 3.5". The small size creates an interesting challenge for the gifted artists who take up the art, and they offer some unique benefits for people who love art.

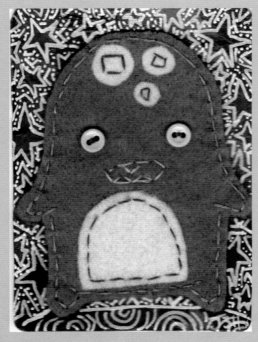

56a. *By Jamila Houde.*

Wrong Fairytale. *By Maria Van Bruggen-Elfies.*

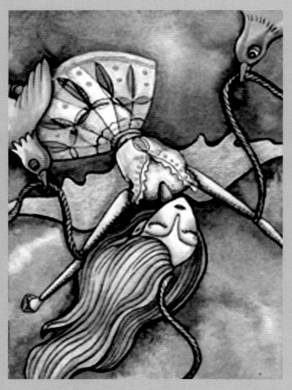

Puppet Angel- Falling Angel. *By Ching-Chou Kuik.*

ACEOs are the modernized commercial offshoot of art trading cards. Art trading cards have been around in many forms throughout history, and they trace their origins all the way back to the sixteenth century when portrait miniatures were all the rage. Back then only Royalty or extremely wealthy merchants could afford to commission artists for paintings. Portrait miniatures became popular because they offered an affordable alternative for the masses to own art. Even many families that could afford large scale family portraits would also have the artist create a miniature of their loved ones faces that they could then carry around like a snapshot while traveling. Portrait miniatures also played a part in arranged marriages. Oftentimes during the process of negotiating a marriage families would hand out miniature portraits of their daughters to advertise their beauty. This caused more then a few unhappy grooms though, since it was a practice of artists at the time to keep their patrons happy by making them look more attractive than they did in real life.

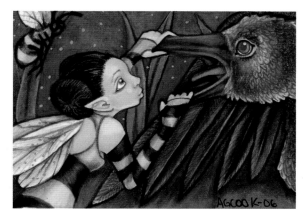

Crows Don't Have Teeth. *By AGCOOK.*

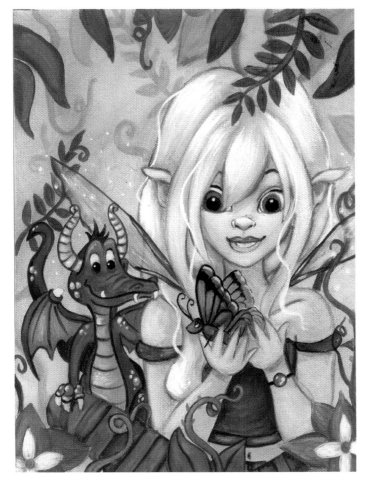

A New Friend. *By Ronne P. Barton.*

Content. *By Susy Andrews.*

Of course that's all a long way from what ACEOs are today. The 'modern' era of ACEOs started with the advent of Impressionism. It was a long-standing tradition that artists would, almost like business cards, trade small pieces of their work with other artists. It was a way for artists to sample each other's techniques and study upcoming

Morgan Le Fey. *By Denise Connell.*

movements. These 'business cards' were called art trading cards, and this practice continues on today in some places. But the Impressionists moved art trading cards away from the artists themselves and into the public eye. They handed out their art cards to wealthy patrons of the arts as advertisements for their works, oftentimes putting an informal resume and their contact information on the back, or they traded the cards in exchange for food, lodging, and art supplies.

Since then ACEOs have kind of always been on the fringes of the art world. Ask many artists or art lovers about ACEOs and they may not even know what you're talking about. However, the last few years have seen an incredible increase in popularity and interest in ACEOs. Many online communities offer chances for ACEO enthusiasts to trade their cards with other collectors, and some cities also have regular card swapping events. eBay.com has become the leading resource for emerging and established artists to try out the marketability of their ACEO efforts and for fans of the genre to add to their collections.

Part of the resurgence of interest in ACEOs is the same as it was back in the sixteenth century. Most of us want to own original art. Many of us would love to have a huge collection of art sampling many different artists and mediums. But how many of us can afford the incredible amount of money that this would cost? How many of us have that much room in our homes? ACEOs solve that problem easily; they are a great way to own a lot of art, by a lot of different artists, on a lot of different subjects, for a very small investment. Many established artists now make ACEO sized prints of their larger paintings in order to get them into the hands of people who appreciate their

work but cannot afford, space wise or dollar wise, the larger original.

The trading factor also makes ACEOs intensely appealing. You can trade for cards that may be normally out of your reach. Or maybe you just love the thrill of the hunt— haggling and trading can become as addictive as the cards themselves! ACEO enthusiasts have a strong sense of community and their events sometimes seem more like a family reunion than a place to get a great deal.

Dragonfly Fairy. *By Nina Bolen.*

Flora. *By Nikki Burnette.*

Little Fairy in the
Flowers. *By Brittany
M. Brewster.*

Pixie. *By Christi Brown.*

Where to Find ACEOs?
How to Showcase Them?

The best place to go to if you're interested in ACEO art is eBay.com, or the similar auction site that features only handmade items, Etsy.com. Simply type 'ACEO' into the search bar and you're up and running. Literally thousands of cards are for sale at any given moment. They can range in prices from merely a penny, plus shipping, to hundreds of dollars. Landscapes, fantasy art (like the cards shown in this book), nudes, surrealism, folk art, and more—anything you can think of ... you can find an art card for it.

The Candy Cane Fairy. *By becki bolton blackburn.*

Fall Migration. *By Sonya Fedotowsky.*

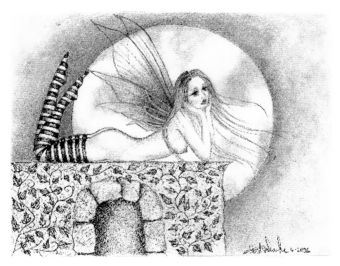

Gothic Dreamer. *By Heidi M. Drake.*

Opposite page:
Under the Arbor. *By Elizabeth Wolff.*

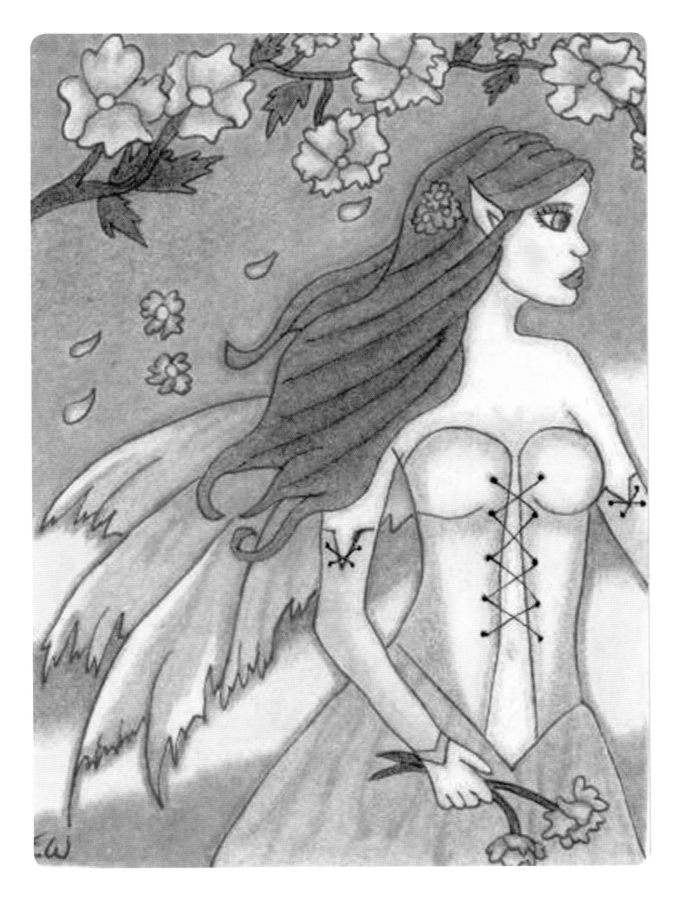

You can also find several online communities that focus on ACEO art, that highlight up and coming artists, and can tell you where you might find a live event in your area. As much as the Internet makes ACEOs available nothing compares to trading in person. Once you start looking around and find an artist you like, check their website for more examples of their work. You'll often find a links section on their website connecting you to the artists *they* find inspiring or links to the on-line communities they use to sell and trade their cards.

Once you have your collection of tiny art, there is almost no limit to the things you can do with them. Slip them into a birthday card and give them as a unique and thoughtful gift. Use a hole-puncher, tie a ribbon through a corner, and use them as ornaments on your Christmas tree. ACEOs are a great supply for crafters. Many people use them in scrapbooks to create truly one of a kind memory sheets. ACEOs also work in decoupage projects.

Another option is to create your own custom coffee table book with your ACEO collection. Head out to your local comic book store or sports collectibles store and buy several sheets of card protectors. Sports card collectors and people who are into collectible card games use these clear plastic sheets to keep their cards in mint condition. The 8.5 x 11" sheets contain nine clear pockets you can slip your cards into, and the sheets fit nicely into any three ring binder. They are PVC and acid free so they will keep your art collection pristine for years to come. You can add pages and change your art around as your collection grows.

Fantasy Valley. *By Juliet Firstbrook.*

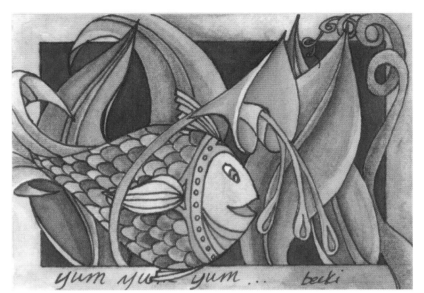

Yum, Yum, Yum.
*By becki bolton
blackburn.*

Magical Forest. By
Denise Connell.

Of course, you can always frame and hang your cards on your walls. You can group them together to create interesting compositions, and since they are small and easy to move around, they work great to update the look of your home as the seasons change. There are also several places that sell hats, purses, and even baby bibs that have plastic pockets to put pictures in, so there's no reason why you can't use your ACEO collection instead!

ACEO display at the Petersen household.
Photo courtesy of Cindy Petersen.

Flights of Fantasy

"It is not only fine feathers that make fine birds."
Aesop

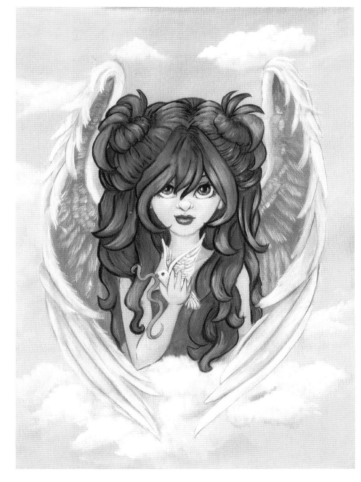

Ribbon of hope. *By Ronne P. Barton.*

More fantastic than any of the creatures made up from pure imagination are those that were somehow based on the very real creatures people came in contact with every day. Probably because of the birds' seemingly unbelievable ability to soar in the sky – an ability no human could safely imitate – there seems to be more myths and legends about flying beasts than any other creature. Whether foretellers, or bringers, of doom or heavenly creatures of prophesy, mythology from around the world is rife with fantastic flying creatures.

Alicante

Prospectors in ancient Chile warned each other about this bird. The glorious animal is seen late at night, brighter than any star, lighting up the night sky as it searches for its favorite snacks—gold, silver, and metal ores. When the Alicante finds veins of precious metals, it devours them until there is no trace left of them to be found. Prospectors try to follow the Alicante, in order to find the rare deposits, and prosper, but the bird doesn't take kindly to being followed. Instead of leading the men to the treasure, it will lure them over the edges of cliffs, rewarding their greed with death.

Griffin

The Griffin, though winged, is not a bird by any stretch of the imagination. It has the body of a lion and an eagle's wings and head. Sometimes it is shown with the tail, and tongue, of a serpent. Because the lion is said to be the king of all beasts, and the snake is so universally feared, the griffin is an especially powerful animal—a king that can fly and one that can kill. In some medieval manuscripts only female

griffins are shown with wings. The creature was also known in ancient Egypt, though in their version the griffin had a feline body with the wings of a falcon. In Turkey the griffin is known as the kargas.

Like dragons, griffins are charged with guarding treasure and other valuable objects. They build nests like an eagle, but lay agates instead of eggs. Griffins are strictly monogamous creatures; they mate for life and remain loyal to that mate even after its death. Should a griffins mate die before them, the surviving of the pair will spend the rest of its life alone in mourning.

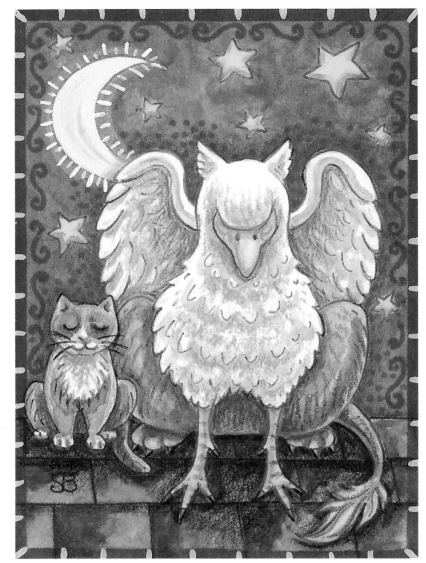

Griffin on my Roof.
By Susan Brack.

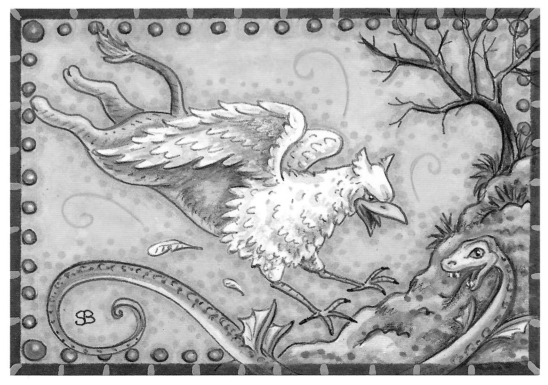

Feathered Foe.
By Susan Brack.

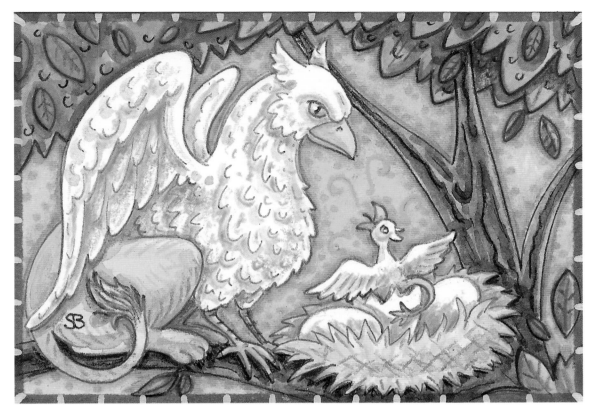

Next Generation. *By Susan Brack.*

Griffins are the sworn enemies of horses, and yet somehow, the offspring of a horse and griffins is not unheard of in mythology. Their offspring, known as a hippogriff, combines the head and feathered wings of a griffin with the body of a horse. The hippogriff, because of its rarity, is usually the pet of powerful mages.

Harpy

Mythology from all over the world is filled with tales of female birds, usually of near demonic nature. The harpy may just be the most evil of these birds. Harpies are a close relative of, and often confused with, Greek sirens.

The harpies have a hag like face, with bare human breasts, atop a vulture's body. Their very name means 'snatcher' and their claws are as sharp as razors. They put their claws to good use by snatching away unlucky humans. Everything a harpy touches becomes foul and poisoned. They take great joy in raining down misery upon poor humans.

Manticore

The manticore is a hybrid creature along the same lines as a griffin. The manticore possesses the furry reddish body of a lion, a venomous spiked, tufted, or scorpion's tail, and the face of a man ... if the man in question has horns, grey eyes and teeth like a shark! In most descriptions the manticore is said to have wings of one sort or another, ranging from feathered like an eagles to leathery and paper thin like a bats.

The manticore is a man-eater. It kills its human prey instantly with even just the smallest of scratches and then devours the body entirely; bones, hair and all.

Manticore. *By Theresa Kenyon*.

Ouzelum

The ouzelum bird is probably the rarest of the mythological birds and that is simply because it is constantly making itself disappear. This strange avian always flies backwards, either to admire its own brightly-colored tail feathers or because it has no idea where it's going and is only concerned with where it has been. As time passes the bird begins to fly in increasingly small circles until it flies inside of itself and disappears for good.

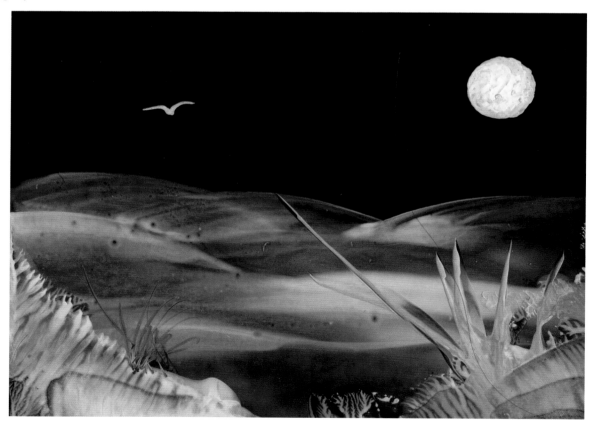

Lilac Grasses. *By Juliet Firstbrook*.

Phoenix

The Phoenix is, arguably, the most well known of the mythological birds. There is only ever one phoenix alive at any given time, living in Arabia (or Africa, depending on who's telling the story) beside a deep cold well. Each morning the bird awakes and bathes itself in the chilling waters. After five hundred, 1,000, or 1,461 years – again depending on which culture's version of the story you hear – the red and golden feathered bird gathers myrrh, cassia, and frankincense to make a fragrant pyre and it lights itself aflame. From the fiery ashes it has resigned itself to, a new phoenix rises up and flies away to restart the whole cycle all over again

The biggest differences you'll find in phoenix stories as you look around the world are in the way it looks and where it came from. Feng-Huang, the Asian version of the phoenix, is normally depicted as a red and purple peacock. In Egypt, where the creatures are called bennu, they resemble large herons, and are said to have been the very first creatures to rise up from the primordial ooze. In Jewish tradition the birds are known as milcham. They lived in the Garden of Eden with Adam and Eve, and were the only creature that could not be tricked by Eve into eating the forbidden fruit of the tree of knowledge. This phoenix was given the gift of immortality as its reward for his loyalty. Other Judaic, and some Christian, versions of the Noah's Ark tale say that the phoenix took great pity on all the work Noah had to do to take care of the other animals and took care of itself, refusing food, in order to lighten Noah's burden. The bird's immortality, and the ability to create another phoenix without there being two parent phoenixes involved, was its reward for helping Noah.

The phoenix can heal itself if hurt by an enemy or in an accident, making it not just immortal but invincible as well. This has caused the more recent myths that the tears and feathers of a phoenix can heal even the direst of wounds.

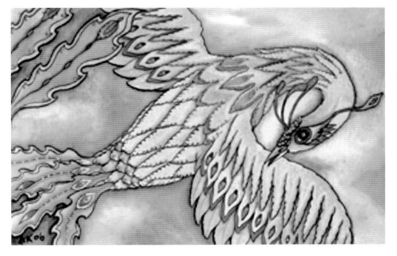

Phoenix. *By Ching-Chou Kuik.*

Colour Cave. *By Juliet Firstbrook.*

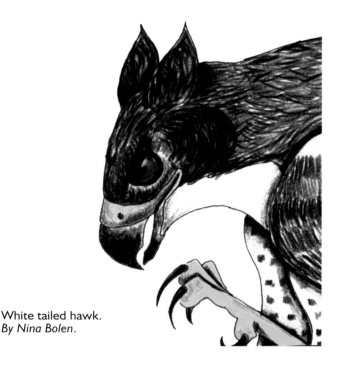

White tailed hawk.
By Nina Bolen.

Roc

Stories of Rocs are found as early as the eighth century in Middle Eastern tales. They are enormous raptors, oftentimes described as being pure white or looking like an oversized eagle or falcon, that are so huge they can swoop down and clutch full grown elephants in their claws, which they then bring to their nests to feed their ravenous young hatchlings. The eggs of the mysterious rocs are so large a full-grown man can't reach his arms around them in the middle and touch hands on the far side.

Even though the name roc is the most well known, both Fiji and China have similar myths about gigantic birds with heroic strength. In Fiji the birds are called kanivatu or ngani-vatu, and they have a reputation for being fearsome man-eaters, as well as plucking whales from the ocean and devouring them whole. The P'Eng, from China, is also linked with fish – though in a much different way. The Chinese say that in the northern seas a rare fish of large girth is sometimes found. They are so few, and so dangerous, no one knows for sure just how big these fishes are, but after they reach a certain size they transform into equally huge birds that take flight for the southern seas, where they eat camels in one massive gulp.

In Maori there is a story of humans defeating a particularly nasty roc, called the pouaki, who had developed a taste for humans and livestock. They weaved together an impossibly big net and baited it with goats and cows from the village. When the pouaki became entangled they dragged the creature to the ground, breaking its wings so it couldn't fly away, and then stabbed it to death. When they started to cut the meat from the carcass, all of their friends and relatives who had been eaten sprang from the bones, alive. Unfortunately, this story doesn't end on a happy note: the survivors had aged drastically within the bird and died shortly after being released.

What is most interesting about rocs aren't the fantastical stories told about them in the classic *The Arabian Nights: Tales from a Thousand and One Nights* or in *The Travels of Marco Polo*. What is most interesting is how the stories most likely got their start. Imagine a bird that looked vaguely like an ostrich, but standing a little more then ten feet high and weighing more than half a ton. It may sound as mythic as some of the creatures mentioned in this book, but up until the sixteenth century or so there were many of these flightless Aepyomis birds occupying what we now call Madagascar. They were commonly known as elephant birds and, because they were covered in peach fuzz rather than full out feathers and couldn't fly, many early travelers who saw them mistook them for the young chicks of a much larger bird.

Safat

The safat is one of the more unusual birds, even as far as mythical ones go. This bird spends all of her time flying, and never comes to rest. Since the safat lacks legs or feet, she can't stop flying even if she wants to. When it comes time for this bird to lay her eggs, instead of building a nest to raise her chicks in, the safat soars as high up into the sky as she can and drops her eggs mid-air. The eggs hatch while they fall, and the chicks are born flying.

Only the shells of these birds ever reach the ground and, alarmingly, folklore tells us that any man or animal that eats the shell will go mad

The Birds. *By Juliet Firstbrook.*

The Simurgh. *By Tiana Fair.*

Simurgh

Ancient Persia and the northern parts of India tell stories of a bird-like creature they call the simurgh. In some texts this bird is clearly a relative of the roc — it's shown as an oversized peacock with a decidedly more vicious appetite. There are tales of it singing beguiling songs to lure all the animals of the forest around, but while enchanted, the simurgh gobbles them up.

Other tales put a different face on the traditional simurgh legends — literally! By some accounts the simurgh was much more then an oversized, veraciously hungry bird. It also had the head of a dog ... and sometimes the face of a human being! A simurgh is almost always female and, although it has the body of a bird, it suckles its young the same as a mammal. It lives in the Tree of Life, and its flight carries the seeds of the tree all over the world. Thus the simurgh is considered a potent fertility symbol. The simurgh is also the oldest creature to ever live. It has seen the world destroyed and rebuilt at least three times.

Siren

In Classical mythology sirens are human headed birds. They are always female and are close relatives to harpies. They live on an unnamed island and sing sailors to their deaths with their aptly named siren songs. The power of the melancholy and beautiful voices of the sirens is legendary. No man can hear their tune and not succumb to them. In some later European stories the sirens are associated with mermaids because of this similarity.

There are conflicting stories about the sirens and their origins. Some say that Demeter cursed them with their feathery shapes for not protecting her daughter when she was stolen by Hades and brought to the underworld to be his unwilling bride. Other stories say that Aphrodite created the sirens from women as punishment for remaining virgins. This is ironic because in many stories the sirens are seen as lustful creatures that lure sailors in, not to cause their death, but for much more carnal reasons.

Russian folklore is filled with bird-women, but as much as they may look like sirens, most of them have a much more illustrious nature. The first of these is called the gamayun and, because it lives close to the gates of paradise, it is a divine creature whose advice is much sought after. Its gifts of prophecy are second to none. The gamayun is usually shown as an oversized blackbird, though some texts say it is every color of the rainbow and heartbreakingly beautiful, and it has the head of an angelic looking woman. So while it may look very close to a classical Greek siren, personality wise the creatures are as opposite as night and day. While an encounter with a siren was feared, and almost certainly spelled death for the person, a visit from a gamayun could drastically change a person's fortunes for the better.

The second of Russia's human-headed birds is so similar to the Greek sirens it even shares the name with them, the Russian spelling being sirin. It sings great songs of joy and future success to priests and saints but, like its Greek cousin, lures the average human to their death with its song. The sirins counterpart is the alkonost, which looks identical to the sirin, but descends from Heaven, singing its lovely enchanting tune to comfort and guide the spirits of the worthy dead to the majesties awaiting them in Heaven. In this way the Russian alkonost can be more closely associated with angels than mermaids, and on old tombstones, pairs of alkonosts were carved on much like angels are today.

The Russians also believed in a male version of sirens, which are missing from almost all other cultures. Called the solovei rakhmatich, this bird hides in trees, watching travelers pass by. When he sees a likely target, the solovei rakhmatich gives a short burst of song to distract the traveler and then robs them blind.

Not to be outdone by Greeks or Russians, there is a human headed pheasant sacred in Chinese marriage ceremonies called Song-Sseu, two siren siblings from Hindu mythology named Sampati and Jataya, as well as an Islamic siren creature known as the zagh. The zagh can converse in every language known to man and is also credited with a divine origin. It is a

close relative of the Islamic murghi-i-adami, which is a pair of peacocks with human faces that whisper to each other endlessly about the secrets they learned while residing in the Garden of Eden. During the Middle Ages many travelers to Islamic countries hoped to overhear the whispers of the murghi-i-adami since not only did they know the secrets of God, but they also gossiped about the future of the people they saw pass by them on the road.

Siren. *By Molly Zirofax Rodman.*

Thunderbirds

Thunderbirds are most well known to us from Native American folklore, but there are many versions of this creature talked about around the world. Thunderbirds are the most universal, and widespread, creatures in Native American mythology. They are talked about in tribes as diverse as the Chinook of the Pacific Northwest all the way to the forest dwelling Alogonquin tribes of the East Coast. Thunderbirds usually appear in the form of an eagle, or a falcon, with a prominent curved beak, and, like the roc, are known for their enormous size and sun eclipsing wingspans. They are the living embodiment of thunder, and depending on the tribe in question, they are sometimes considered to be gods in their own right. With a few flaps of their huge wings they can call up a fierce storm and they keep supernatural 'lightning snakes' beneath their wings. Thunderbirds are also connected with war, as they are said to be mighty warriors in their own right who often battle with supernatural creatures. Their favorite food is the killer whale, and great battles between the two are said to be the cause of treeless prairies.

Of course within the tribes themselves there is much variation on the appearance and habits of the thunderbirds. The Iroquois say that the great chief of the thunderbirds is a golden eagle named Keneun that is known by the lightning he sends, but is never seen himself. The Dakota tribes call their thunderbirds the wakinyan; they have four of them, each of a different color and hovering in one of four different directions — north, south, east, or west.

The raicho is the Japanese version of the thunderbirds. A raicho lives in a pine tree and is indistinguishable from a common rook, until it opens its mouth and beats its wings, calling up mighty storms. In the Western Hemisphere this idea of enormous thunderbirds is found as south as South America, where the birds are called xexeu, and as far north as the Inuit people of Alaska, where they are called tinmiukpuk, and are well known as hunters of caribou. The tinmiukpuk are not above eating humans, if caribou grow scarce.

Zshar-ptitsa

In Russian folklore the zshar-ptitsa is a magical firebird, somewhat like a phoenix, whose feathers bloom with all the colors of a pyre. Even when plucked from the body of the zshar-ptitsa the feathers emit a strong enough glow to light up a darkened room. The firebird sits upon a gold perch and eats golden apples that give youth, vigor, and immortality to anyone who eats them. When the zshar-ptitsa sings enormous pearls fall from its beak and the sound of its voice can heal the sick and cure the blind.

My Bird. *By Maureen Craven.*

Under the Sea

"Not everything that dives into the water is a mermaid."

Russian Proverb

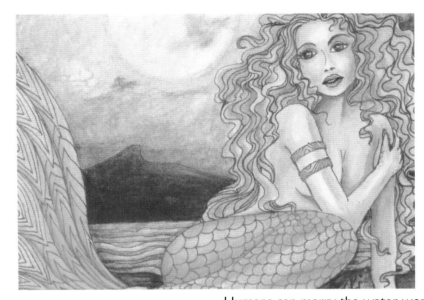

Moon Glow.
By becki bolton blackburn.

Although humans mastered the art of sailing fairly early in history, the true depths of the ocean, and even most lakes, were as off limit as the sky. Sailors left for adventures that sometimes took years to complete. They often saw wild things, unexplainable by the science of the times, or grew so bored they made up tales to pass the time. When they returned to their families they brought home tales of the monsters, and the great beauty, that lived in the deepest parts of the deep blue sea. Sometimes these sailors did not come home at all, and their unexplained disappearances created as much mystery and lore as the things they made up themselves.

Dona D'aigua

Spanish for 'the water women', the dona d'aigua are beautiful ladies who live in freshwater lakes, or even just very full wells, and can turn into birds at will. Chillingly, the dona d'aigua will use long hooks to snatch any child that walks too close to their watery homes and drag the child under with them. Even so the water women are said to be very good mothers.

Humans can marry the water women, if they agree to some carefully worded terms that put even the sleaziest of lawyers to shame, but it usually ends up poorly for the hapless husband. Inevitably the human will eventually unwittingly break the agreement and the water woman will return to the waters from whence she came, taking the family fortunes with her and leaving her children behind. However it cannot be considered total abandonment as the dona d'aigua returns each morning to dress and bathe the children.

I am of the Sea.
By Renee Lavoie.

29

The dona d'aigua are known for their foul tempers, it is even said that if you make them mad the very water they live in will boil. They are also extremely narcissistic, and spend hours watching their reflections in the water and brushing their shining gold or red hair. The water women have blue or green eyes, and can live thousands of years. They do their best to avoid humans whenever possible, and even though they steal children, are said to bring much wealth and good fortune to the areas around the lakes and wells they call home.

Sunshine Turtle. *By Olga Ziskin.*

Opposite page:
Wake Up.
By Olga Ziskin.

Makara

A makara is a play on the traditional mermaid or merman. It has the classic mermaid bottom half of a fishy, scaly tail but its upper half can be any animal imaginable. They usually have no real power of their own and simply act as pets for the amusement of mermaids.

The exception to this is seahorses. They are the ichthyocentaur, who is sacred to the goat God Pan and a semi divine fertility symbol in his own right, and the hippocampus, who pull the sea God Poseidon's chariot through the waves. There are many myths about the hippocampus and their amazing abilities. They are known to come to a certain island just once a year to graze on the special grasses there. Ancient Egyptian horse herders would bring their mares there at the same time in the hopes they would mate with the hippocampus. The offspring of a horse and a hippocampus created a foal that could run without stopping because they were born with no need to breathe air.

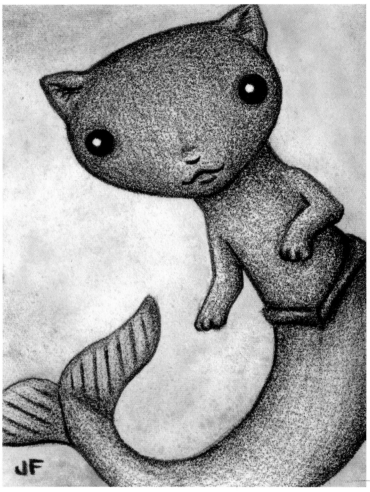

Cat-Fish. *By Jamie Fales.*

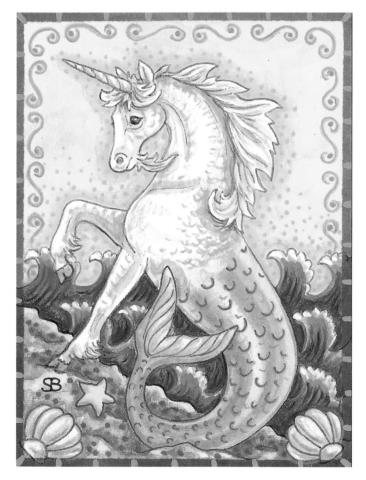

Born of the Sea.
By Susan Brack.

In Medieval bestiaries these horse fish hybrids are called the hydrippus. They are the farasi bahari in Swahili.

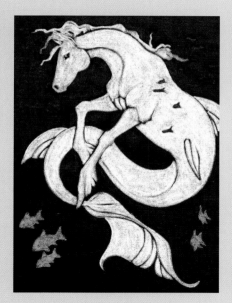

Hippocampus. *By Misti Hope Wudtke*.

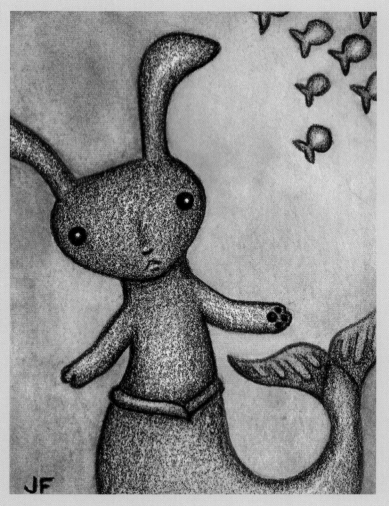

Bunny Fish. *By Jamie Fales*.

Mermaids

Sailors throughout history have delighted in the idea of mermaids, who are beautiful young woman from the waist up, but have scaly fish like fins below. Mermaids are often seen on rocks at the waters edge, brushing their hair or gazing in mirrors at their lovely faces, and singing with the voices of angels. Their beauty is legendary, though sometimes, even in human form, their fishy nature shines through, giving them webbed fingers or a slightly greenish hue. Mermaids are extremely long lived, and usually retain their pretty youthful appearance throughout their long lives, but they are not immortals. Though nowadays we think of mermaids as kind gentle creatures with spirits as sweet as their voices, in the earliest stories mermaids raised storms that put the lives of sailors in jeopardy, or delighted in singing a sweet song that enchanted sailors and caused them to run their ships against the rocks where she lounged. The sound of a mermaid's siren song is utterly irresistible, even though it was well known that it foretells, or causes, disasters at sea.

Some stories also tell us that mermaids can grant wishes, or that when caught they can pay their own ransom. Mermaids, and the mermen who accompany them, live in opulent undersea palaces and own enormous treasures. The merfolk salvage the luxurious goods from sunken ships, and the creatures of the sea pay them tribute by bringing them the pearls and jewels they find along the sandy bottom of the ocean.

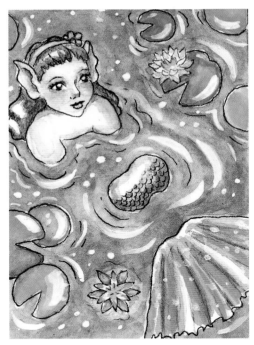

Eve, Little Pond Mermaid.
By Denise Lopez Ramirez.

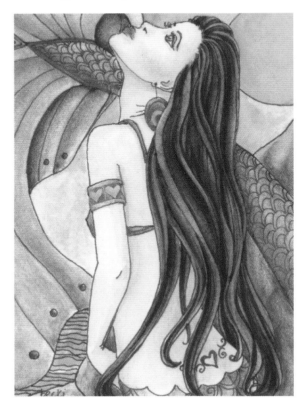

Tattooed. *By becki bolton blackburn.*

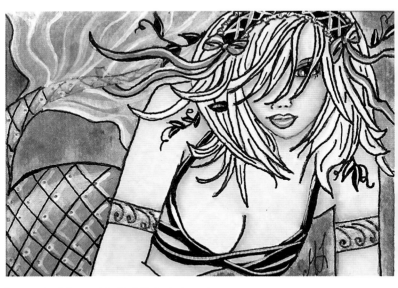

Lavender Mermaid. *By Michele Lynch.*

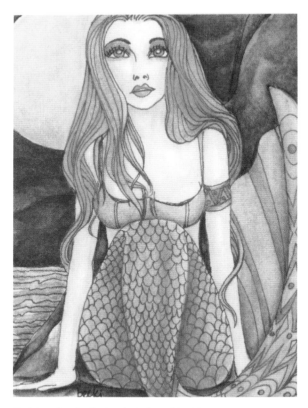

Golden Goth. *By becki bolton blackburn.*

Nadia. *By Michele Lynch*

The Japanese version of mermaids is called ningyo, and while they might call down storms and ill fortune if caught, overall they are seen as talismans that ward off bad luck. While in most other cultures partaking of the flesh of a mermaid is a taboo that would rain curses and bad luck down upon your head, or even turn you into one of the aquatic maidens, the Japanese believe that if you eat the flesh of a ningyo you will be granted with immortality, or at least a very long life.

The most common stories about mermaids are of them, usually unwillingly, marrying a human. Some traditions hold that mermaids can slip their fins off like scaly articles of clothing and walk the beaches at will, or that they wear small caps or belts they leave behind on the beaches when they come up to sun. Any man who finds a piece of a mermaid's clothing can force the fishy maiden to marry them. They are said to make dutiful, though very melancholy, wives. Stories say that mermaids can bear human children. The downside of wedding one of the merfolk is that if they ever discover where you have hidden their clothing away they turn back into fish form and make for the sea, sometimes taking their human children with them, sometimes leaving them behind, but either way the unhappy wife is never to be seen again.

Opal Beauty. *By becki bolton blackburn.*

Temptress. *By Denise Lopez Ramirez.*

Pearl. *By becki bolton blackburn.*

There are many different names for mermaids across the globe, even if the stories about them are very nearly the same. They may be known as the aycayia, ben varrey, clytie, gwyndwy, havfine, havfrue, ikalu nappa, mami wata, mari morgan, merrow, roane, rusalki. As the Slavic rusalki they have see through skin and are thought to be the spirits of drowned virgins. They can turn into both fish and horses at will.

Second Thoughts. *By Rochelle Angelique Ortiz A.K.A Teardrop.*

36

Mermaid with Purse. *By Molly Zirofax Rodman.*

prospered. The boy was so thankful he planted an apple tree on the cliff above the harbor where the mermaid lived to she would be able to get apples herself as they fell from the branches. But things took a turn for the worse for the well intentioned young man when the mermaid grew tired of waiting for the apple tree to mature. In a fit of rage she called up a storm while he was out fishing and he was lost at sea. Bad luck followed his family from that time forward and the mermaid was never seen again.

This story from the Isle of Man perfectly captures the capricious nature of the mermaids, known in that area as the ben varrey. A young man was about to go fishing one day when a beautiful mermaid swam up to where he was packing his boat and inquired about the health of his father. The boy was amazed to find out that his father and the mermaid were old friends. When he asked his father, who was gravely ill at the time, he was told that as a young man his father came across the mermaid while fishing and shared his lunch with her. The young mermaid discovered an appetite for apples so the man made it his custom to bring her a bag of them whenever they were in season. The old man told his son that he was too ill to bring the mermaid any more apples and that he must carry on the tradition.

Quite taken with the beauty of the mermaid the boy was more than pleased to bring her apples whenever he got the chance, and the mermaid would sing for him. Almost immediately good luck began to rain down on the family. The father regained his health, every fishing trip they made resulted in the largest catches anyone had ever seen, and the family

Pearl of the Ocean. *By Roselle Kaes.*

38

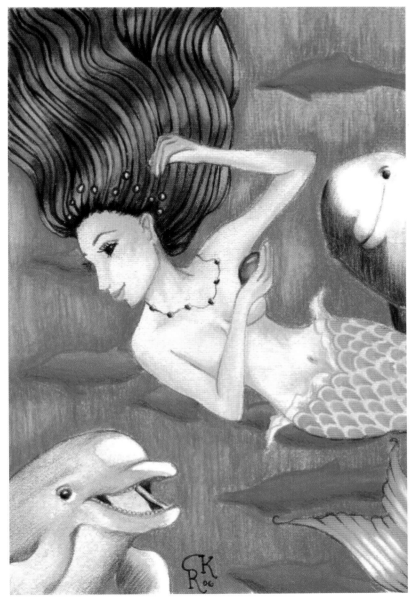

Playing. *By Roselle Kaes.*

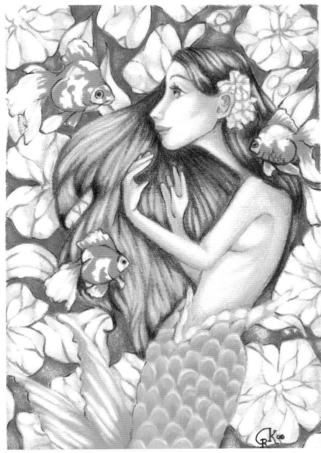

Opposite page:
Yayoi. *By Roselle Kaes.*

Conversations with the
Ruykin. *By Roselle Keas.*

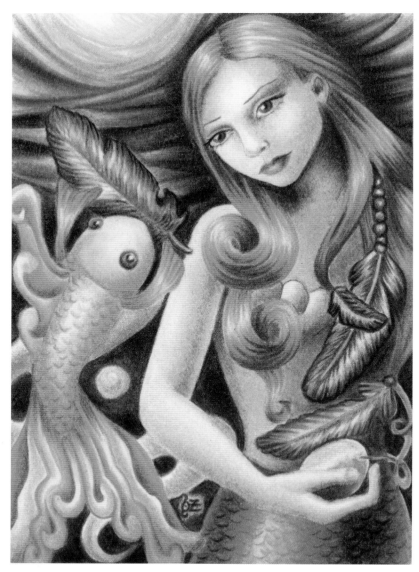

Messenger. *By Olga Ziskin.*

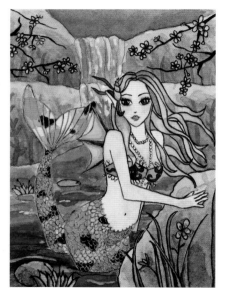

Felicity. *By Nikki Burnette.*

then the little mermaid will turn to sea foam and die.

Desperate at the thought of having a chance to be with her prince charming, the little mermaid agrees to the deal. But at the end of the third day her beloved prince is sound asleep, in bed with his new wife. At the last moment the little mermaid's older sisters strike a deal of their own with the sea witch. At the cost of their shining hair the sea witch gives them a ceremonial dagger. If they can convince the little

We usually don't think of mermaids as being so fickle. Our most common image of the sea-maiden is that of Ariel, the red haired mermaid princess from Disney's *The Little Mermaid*. What many people do not realize is that the popular Disney movie is based on a much older tale by Hans Christian Anderson, a tale that is not quite as, well, ... disney-fied as the recent movie version. In the original story of *The Little Mermaid*, written in the early 1800s, a young mermaid princess unwittingly falls in love with a human prince. An evil sea witch learns of the young mermaid's plight and offers her a terrible bargain. The sea witch will give the little mermaid legs, in exchange for her voice, but every step she takes on those legs will feel as though she is walking on sharp knives. The mermaid will have three days to make the prince fall in love with her, at which time she will remain a human forever. If she cannot gain the true love of the prince,

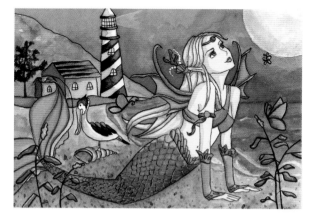

Gwyneth. *By Nikki Burnette.*

mermaid to kill the prince as he sleeps in his marriage bed, she will be allowed to return to the sea. In the end the mermaid loves her prince too much to see him die, and instead kills herself.

Mermaid myths go back as long as there were humans around to talk about them. Perhaps fittingly some of our earliest human civilizations told stories of the first mermaids, ones who had a grimmer beginning than you'd suspect. The Babylonians, and people of Mesopotamia, say that the first mermaid was actually a half whale, half dragon monster that was birthed by the Goddess Ishtar. Meanwhile the Syrians say the first mermaid was actually a moon goddess and mother of their legendary Queen Semiramis, Atargatis. Atargatis fell in love with a human shepherd, but it is not easy for a human to be the lover of a Goddess. When the shepherd died from their love making Atargatis was so ashamed she threw herself into the sea and tried to disguise herself as a fish. But the waters refused to let her relinquish her divinity and instead she spent the rest of her life as a woman above the waist, and a fish below. Atargatis would become an important fertility Goddess to the Babylonians whose worship of her was widespread in its day. Hence, they are credited with carrying the tales of mermaids far and wide throughout the known world.

Mermaid Dreaming. *By Maureen Craver.*

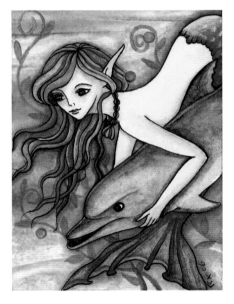

Swim with the Dolphins.
By Ching-Chou Kuik.

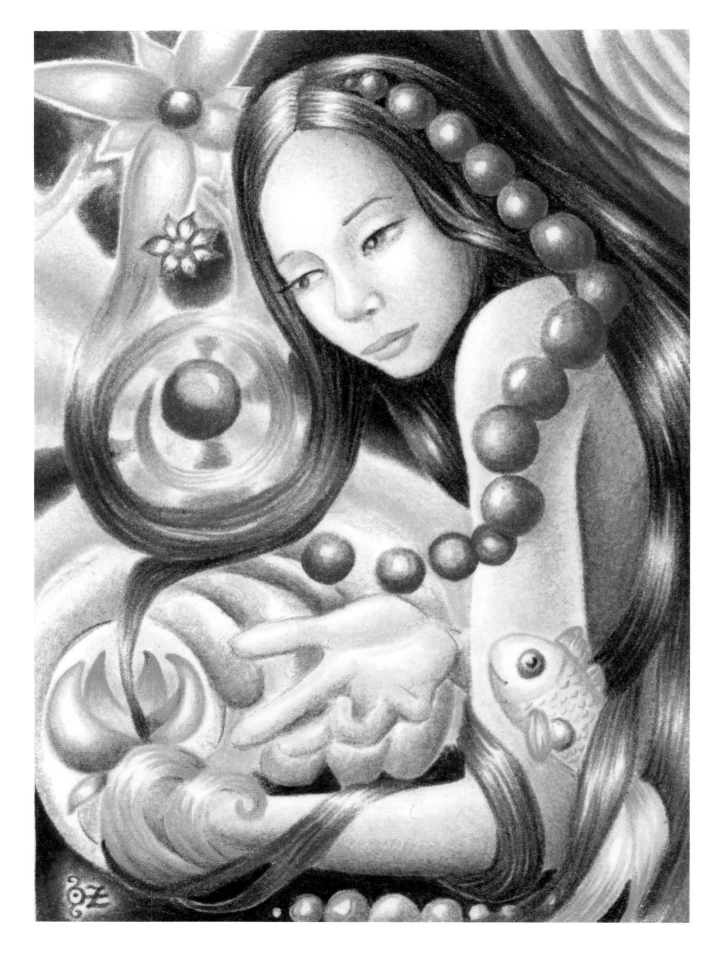

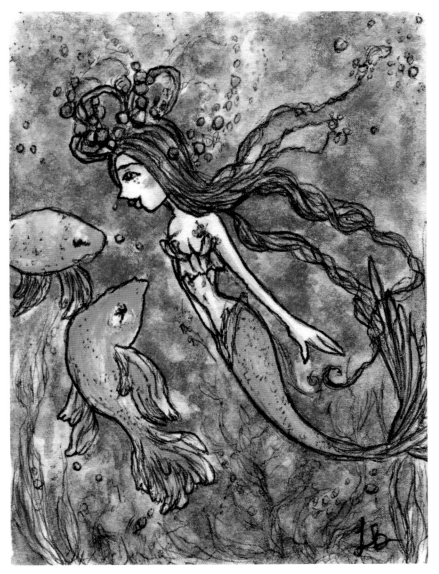

Delphina. *By Lorelei Bleil*.

Mermaid Portrait. *By Maureen Craver*.

Atargatis is not the only divine mermaid. In the Maori tradition, ngarara are beautiful goddesses who take the form of mermaids, sometimes with a more amphibious look than that of our modern mermaids, and who can retract their tails at will and walk the beach as a regular women. However, since the transformation isn't complete, the ngarara can only spend short amounts of time out of the water. They can extend this time by keeping their hair wet to keep themselves from drying out. The ngarara had an ominous habit of trying to turn humans, invariably men, into merfolk like themselves by slipping a few of their scales into food they would then serve as a meal to the human.

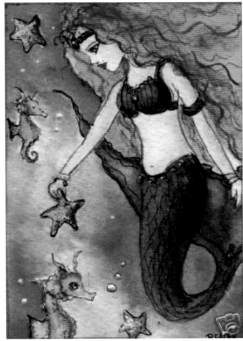

Catch a Falling Starfish. *By Renee Lavoie*

Opposite page:
Illusionist. *By Olga Ziskin*.

Probably because of their earlier association with fertility, during the reign of England's much-celebrated Elizabeth I, mermaids became a symbol for prostitution. As an insult, because of this association with loose women, they were also used to represent Elizabeth's great rival, Mary, Queen of Scots, in the political cartoons of the times.

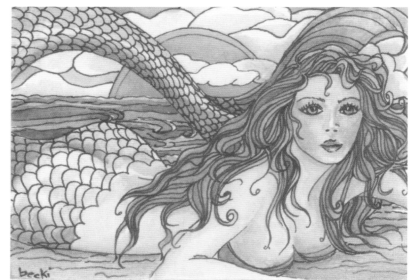

Violet. *By becki bolton blackburn.*

Mermen

Of course with all these lovely mermaids swimming about it should come as no surprise that there are stories of their male consorts — the mermen. Perhaps because they have such lovely fishy ladies to protect, or such vast treasures to keep from being stolen, mermen are usually seen as quite a bit rougher then the mermaids. They are associated with great storms that wipe the sea clean of all ships, and are easily angered by any harm coming to the inhabitants of the sea. Mermen are jealous and cruel husbands who sometimes eat their own children if they become hungry enough. Less commonly they are seen as gentle and wise teachers from the sea.

Physically they differ quite a bit from their feminine halves. While they are still fish below the waist they are slightly less human above. Typically the mermen have scaly green skin all over, seaweed for hair, and sometimes even fierce glowing red eyes. In some cultures mermen look more like the creature from the black lagoon then they look like our usual idea of half fish, half humans. The Scandinavians eschewed this idea of grim mermen, their havmand, as they called them, are quite handsome and are sometimes depicted with a neatly trimmed black or green beard.

Like mermaids, mermen are also associated with many early stories with Gods and Goddesses. Oannes is a fertility God from early Babylonian and Sumerian myths that was part man and part fish. They said he lived in the Persian Gulf by night, but by day came ashore and taught humans writing and the arts. In Thailand's mythology it is a merman God named Machanu that guards the lake entrance to the underworld.

From Greek mythology we get the tale of Glaucus, a human who became a merman. Glaucus was a fisherman and one day, after placing his catch on a particular bed of grass, the dead fish came back to life and hopped back into the ocean. Intrigued Glaucus ate some of the grass. He became immortal, but he also grew a fish's tail and fins in place of his arms. Glaucus was, understandably, upset by his transformation, but he was well received by the existing merfolk and was taught the art of prophecy. Glaucus grew to accept his new life, but maintained a great affection for the humans he left behind. He would go on to be a protector of fishermen and sailors lost at sea.

55a. *By Jamila Houde.*

The Merman. *By Tiana Fair.*

The Peloponnesians beat them all out on inventiveness though; in their mythology mermaids and mermen are the children of a fish God, and they are split half human half fish vertically rather the horizontally. By walking carefully to only show their left sides, they pass as full humans and enjoy Peloponnesians markets and fairs, but if anyone ever catches a glimpse of their right sides they are exposed as the fish they actually are.

Samebito

We learn of the samebito from Japanese mythology. This creature is somewhat like a mermaid, or mermen since most tales talk about the male of the species, in that it had the upper half of a human. However it's lower half was decidedly shark like. The samebito had inky black skin, bright green eyes, and an unruly beard.

Selkie

Scotland's selkies are associated with the same types of stories as mermaids — that is to say there are many tales of selkies unhappily, and against their wills, being married to humans. As in mermaid myths, the selkie eventually finds the skin the human has used to bind them together and takes off for the ocean waters, sometimes taking their half human children along with them under the waves.

What makes selkies different from mermaids is most obviously seen in their appearance. While a mermaid, or merman, is half human / half fish, a selkie is actually a seal. Usually described as being one of the larger species, a grey or crested seal, it is only when they come to land to bask in the sun that a selkie removes this seal skin and turns into its human form. It's at this point that a lucky, or unlucky since such marriages never seemed to end up happily, human finds the seal skin hidden behind a rock and takes the selkie as his mate.

Some traditions say that selkies are angels who were driven out of heaven. Others, more ominously, say they are wretched humans who must live out a term of purgatory in the shape of seals.

The leader of the selkies, their great king who is referred to as the Great Selkie of Sule Skerry, had a habit of wooing mortal women he found on the Shetland Islands. There is a great ballad that speaks of one of these unions that resulted in the birth of a child. When the Great Selkie of Sule Skerry came ashore to collect his son, the human woman refused to admit that he was the father. Outraged the Great Selkie tossed her some coins that he rather offensively called a wet nurses fee, and took the child away. The Great Selkie had a gift of prophecy and, even as he was reunited with his child, he knew they were both doomed to die at the hands of a seal hunter, who was the husband of the young selkie's human mother.

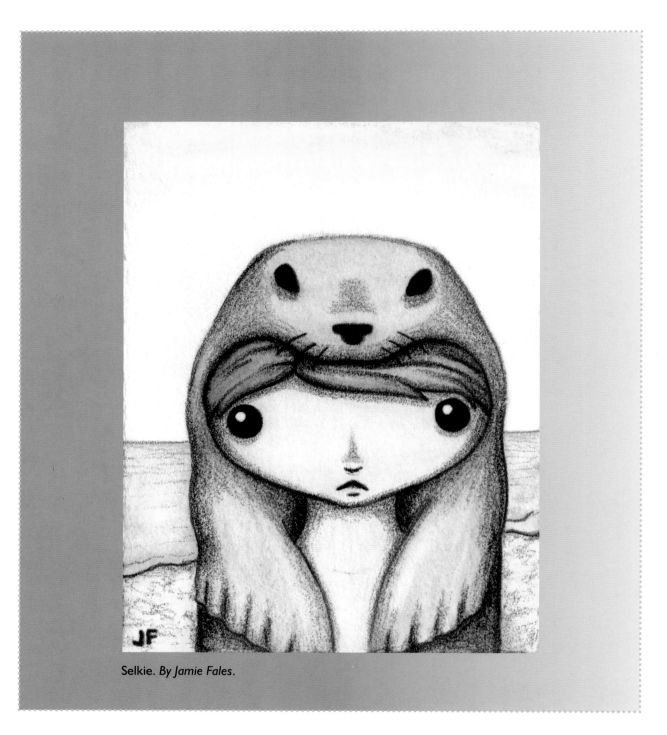

Selkie. *By Jamie Fales.*

Tritons

In classical mythology there is a unique take on mermen called the tritons. The tritons were half man, with dolphin like bottom halves, rather than fish. The tritons were the sons of Poseidon, a merman and God of the sea, and they announced his arrival with music and horns created from shells.

The Fair Folk

"I think that people who can't believe in fairies aren't worth knowing."
Tori Amos

A Shy Little Fairy. *By Ronne P. Barton.*

Better known as the fey, fae, or fairies, 'the fair folk' is something of a euphemism that humans call the following creatures to stay in their good graces. Most of them aren't particularly frightening, but they do have their mischievous side and, perhaps because they are so different from us, unknowingly their tricks can turn mean.

Out of all of the mythological creatures, the fair folk are probably the hardest to pin down. They are usually small flighty creatures that prefer working quietly behind the scenes, invisible to the human eye. They share many of the same traits and tricks, blurring the lines of where one fey creature ends and another begins. And, because they are so beloved in modern mythology and fantasy tales, there is an almost un-limited variety to each type of fey creature.

Banshees

The name banshee may mean 'woman of the fairy mound', but there is nothing sweet and pixie-ish about her! Banshees are the ghosts of women who have been murdered, or died in childbirth. They are known for their keen, shrieking wail. The oldest stories say that the sound of a banshees' cry foretells the death of someone from one of the great Gaelic families, namely the O'Connors, O'Briens, Kavanaghs, O'Grady, or O'Neills. As time has progressed the banshees' wail has come to mean the eminent death of anyone and, if several banshees appear at the same time, then someone Holy is doomed.

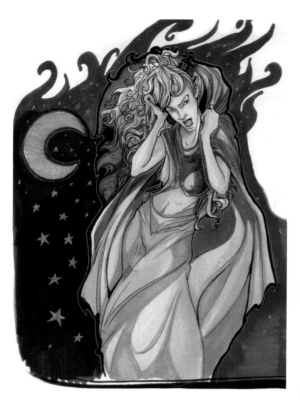

Banshee. *By Molly Zirofax Rodman.*

Banshees appear as ghosts, dressed in a white, grey, or black cloak, with long wild hair. They carry a silver comb to brush the tangles from their hair, a comb that is often misplaced and left behind for humans to find. The comb, however, is no innocent souvenir of the uncanny. Any human that picks the comb up will be spirited away by the banshee who left it, never to be seen again.

In Celtic or Scottish legend banshees are called the bean nighe, a name that literally translates to the washer at the ford. She is a wraith like hag of a woman who appears, while washing blood stained clothing in the ford, to warriors as they head off to battle. Like the banshee she is a foreteller of death, in this case the warriors own.

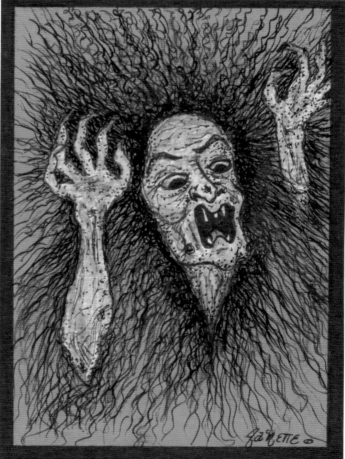

Banshee. *By Janette.*

Brownies

Brownies have been described as a type of fairy, to a dwarf, to everything in between. If you're a Harry Potter fan you're already familiar with what brownies do. The character Doby is the epitome of what a brownie is, and in different places brownies are known by the names doby, dobby, dobi, dobbie, or dobbi. They are usually dwarf sized, or smaller, and almost goblin-like in appearance. Brownies willingly, or otherwise, enter into service to a household.

Most often they work on their own, sneaking into a house at night to finish any task that has been left unfinished. In what is probably the most famous of these stories they sneak into a cobbler's house at night and finish shoes for him while he sleeps, creating footwear of the finest craftsmanship.

Although the German version of brownies, the heizelmannchen, are practical sorts that help those who have already helped them, in some way in most cultures no one is quite sure why a brownie decides to work in one house rather than another, though they will continue to come around as long as you leave a small token of gratitude for the work they do. Small dishes of fresh milk, or some pieces of bread, are usually enough to keep them satisfied and working hard. According to tradition brownies will continue their nightly work until the master of the house gives them an article of clothing they can call their own. In the case of our famous fairytale cobbler, he made the brownies sets of small finely made shoes as a way of saying thanks and unwittingly set them free from his service.

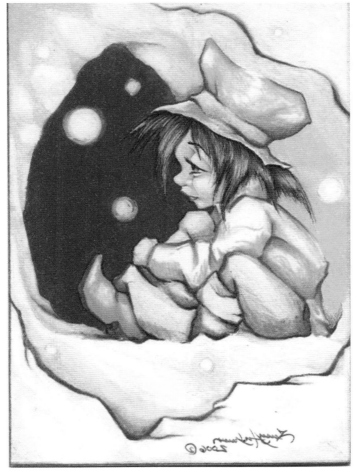

In Scandinavian countries brownies are called tompte and acquiring one is not left up to shear luck! Because the tompte brings so much prosperity to the homes they live in, they are sought after with the help of several elaborate rituals. And the wooing of the tompte doesn't stop once a household snags one of their own. Once in service to a home, the tompte is fed twice a day, at strictly regulated times, and are given every Thursday off, at which time they are fed especially well. Keeping the tompte happy is serious business. If the tompte becomes annoyed with his household due to untidiness, or loud noises, he can become a terrible bother that pinches the babies awake, brings poor luck, and lets the livestock run wild.

Brownies are almost exclusively seen as male, except in Russia where they are the always-female kikimora. A kikimora looks much closer to a fairy than a traditional brownie. She is extremely small and delicate, though she appears to be of great age, sometimes with a hunched back. Like a brownie she does simple household tasks while the family sleeps. If the family grows lazy about housework, however, they'll find their sleep disturbed by her banshee-like wailing and screeching. She loves to spin cloth, but it is said that any human who catches her at her spinning wheel will die soon after.

There is a special offshoot of brownies called the hobs that watch over children and cure them of disease whenever possible. They also must never be given clothing or they will leave the house's service and go on their merry ways.

Waif. *By Susy Andrews.*

49

Elementals

Elementals can be described as a spirit or primordial fairy whose power, appearance, and nature is linked to one of the four elements, namely earth, water, air or fire. Elementals are protectors, as well as powerful wielders, of their element. They are often invoked in magical ceremonies so neo-pagans or magicians can borrow their power and force for their spell. The elementals, for the most part, seem to simply be names given to powerful nature concepts by mages in order to make them easier to concentrate on or invoke. The elementals play no part in the accepted ranks of mythology, but have come to be an important part of modern fantasy stories where they are described as anything from invisible currents of power, to elfin, nymph, or fairy like creatures.

The four generally accepted elementals are sylphs (air), gnomes (Earth), salamanders (fire), and undines (water). In our modern mythology, fantasy books, and role-playing games, elementals have come to encompass all things of nature resulting in everything from lightning elementals to forest elementals.

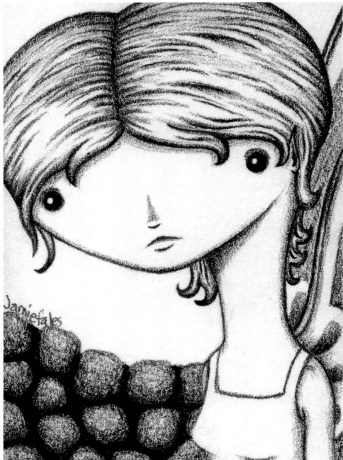

Sadie. *By Jamie Fales.*

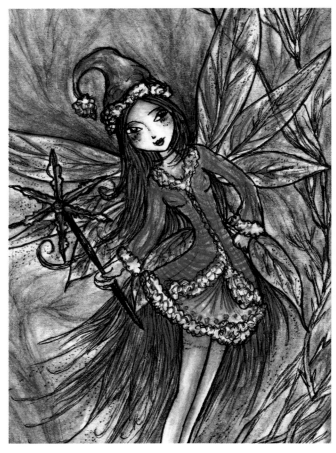

Frost. *By Lorelei Bleil.*

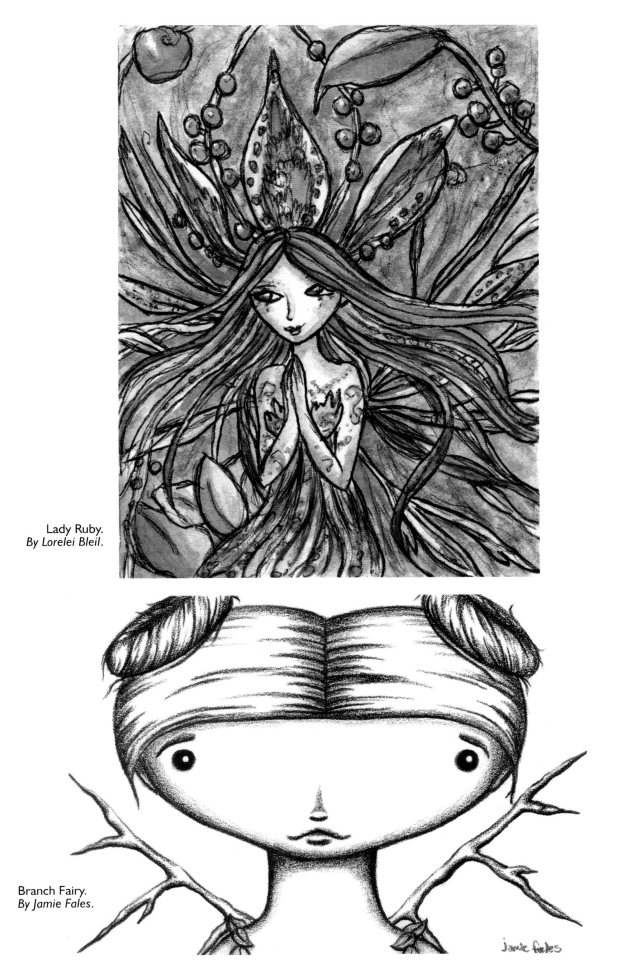

Lady Ruby.
By Lorelei Bleil.

Branch Fairy.
By Jamie Fales.

jamie fales 51

Elves

Elves are the oldest of the fey folk, and the loveliest. They are more beautiful then any human imaginable, tall and lithe, with an angelic serene nature. Rarely they may have green skin, and almost always have elongated, pointed ears. In Norse mythology elves are immortals and minor nature deities in their own right. Even cultures that do not grant them such lofty origins say that they are so extremely long lived that they may as well be immortal.

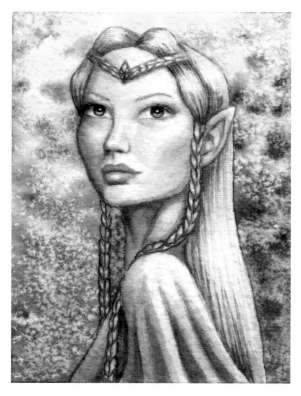

Amethyst Elf. *By Sonya Fedotowsky.*

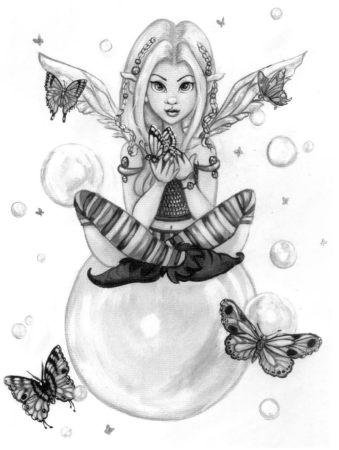

Butterfly and Bubbles-Gold.
By Ronne P. Barton.

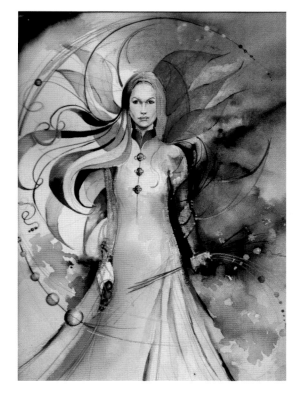

Sky Goddess. *By Denise Connell.*

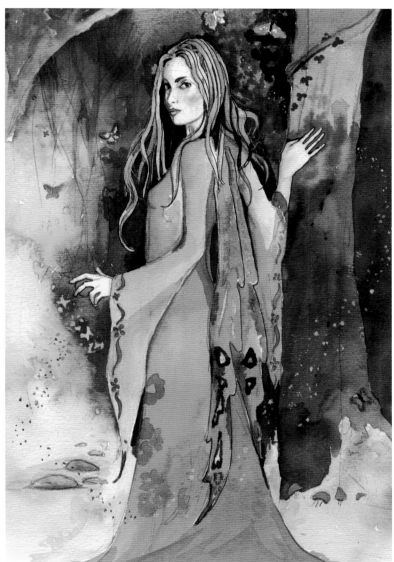

Butterfly Wood. *By Denise Connell.*

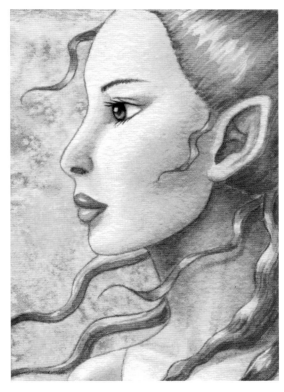

Elf Sisters-Red. *By Sonya Fedotowsky.*

Good-natured, Elves use simple, natural magic. Most of their power derives from their vast knowledge of the forest and the properties of plants that grow there. Elves were also known, much like dwarves, for creating the finest magical armors and weapons. They were great seamstresses who produced invisible cloaks, and other ability granting garments. Because of their incredibly long lives elves are wise and many have the gift of prophecy on top of the wisdom they collect through the ages.

Norse mythology holds that, much as there are good and evil fairies, there are good and evil elves. The good elves, called liosalfar, are brighter than the sun, and as pure, and live in the sky. The dark elves, the svartalfar, are so black the human eye cannot see them and they live in the deepest, darkest bowels of the Earth, along with far tunneling dwarves and the blackest of demons. The svartalfar should not be mistaken with the underground race of Norse elves called the landvaettir. These elves are important guardians of the land and were once so well respected that any ship with a frightening prow would cover the offensive image so as not to frighten the landvaettir away.

Niamh. *By Denise Connell.*

Gypsy Fairy. *By Nina Bolen.*

Cerulean Goddess. *By Denise Connell.*

Elfin Girl II. *By Maureen Craver.*

Brazil's elves are much more human, and fairy like, than elves elsewhere. Their most famous elf is Pombero, a trickster who spends his time helping livestock escape from fields and keeping children from chasing birds. He is a bit of a rogue, visiting women at night when they are alone, and impregnating them with a touch of his hand.

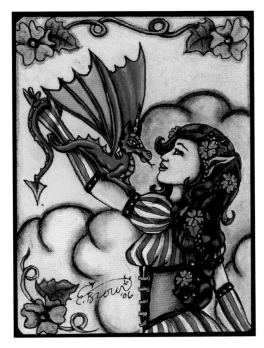

Dragon Kisses. *By Christi Brown.*

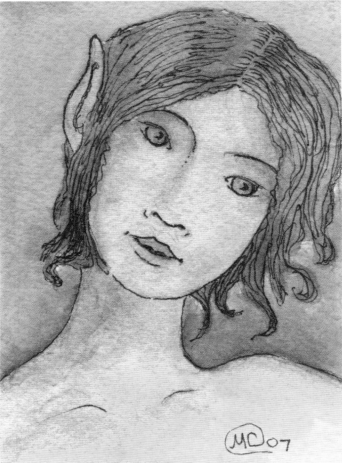

Elfin Girl. *By Maureen Craver.*

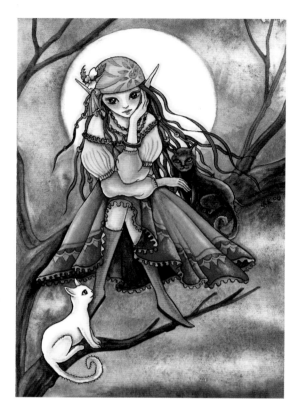

The Visitor. *By Ching-Chou Kuik.*

Fairies

The word fairy is used to describe a lot of different types of creatures. In many places the word can be applied to any magical being—whether they are a goblin, a changeling, or even a gnome! For the most part though our modern idea of a fairy is a small winged human, who may or may not have a wand, and usually has some type of magical powers. Oberon is named as King of the Fairies by sources as diverse as William Shakespeare to romantic poetry. Fairies are often identified as being protectors of nature, kindly spirits of the forest, or streams and lakes. Most often their magic is of the elemental kind, and many people believe that different races of fairies are associated with different elements (fire, water, earth, and air), the four seasons, or where they live (i.e. in a tree, by a stream, near a cave).

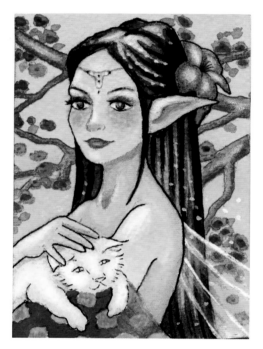

Good Company. *By Dense Lopez Ramirez.*

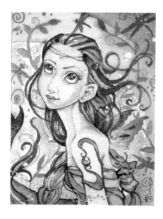

The Dragon Fly Faerie. *By AGCOOK.*

Fairies are usually seen as being quite lovely, often scantily clad, and are almost always female. They are said to have capricious natures, everything from being sensitive and temperamental to being annoying little gnats that love to pinch and tease any human unfortunate enough to cross their path. Most often their tricks are harmless, if irritating, like hiding items you need, spoiling milk, or luring travelers astray on their path. One of the favorite past times of fairies is snarling the hair of sleeping humans. Fairies are almost insatiably curious about humans and some, Wales's tylwyth teg fairies for example, love to disguise themselves in human form and visit our fairs and market. They spend vast sums of money buying ribbons and mirrors, anything glittery that catches their eyes, but alas! When the poor merchant or farmer leaves the fairgrounds he'll find the money that he's been paid has turned into dried autumn leaves.

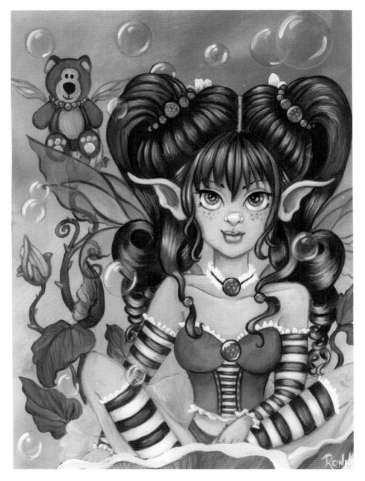

Ode to Green Bear. *By Ronne P. Barton.*

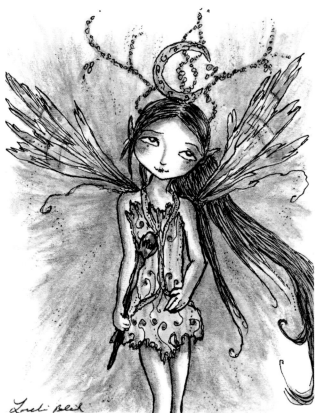

Leda Moon. *By Lorelei Bleil.*

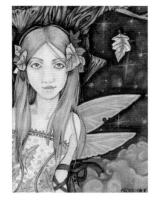

Fall Fairy. *By AGCOOK.*

Asian Fairy. *By Heidi M. Drake.*

Even though we almost always see fairies as winged creatures that has only been the vogue since the Victorian era; when you look at fairies in the past they almost never are depicted with wings. However, even without wings, fairies have always been known to fly, as magic does have its advantages over physical form. Because they are beings of almost pure magic you don't find usually find stories about them associated with money or treasure, like you do with leprechauns or dragons. But Catalonian folklore is rife with stories about negrets, tiny dark skinned fairies who, if you hold a candle to them, turn into a pile of gold coins. The other exception is the laminak fairies of southern France who live underground, and like dwarves, have vast underground palaces covered in gems.

Green Eyed Fairy II. *By Maureen Craver.*

Teasing the Kitten. *By Christi Brown.*

Sapphire Fairy. By
Stephanie D. Fizer.

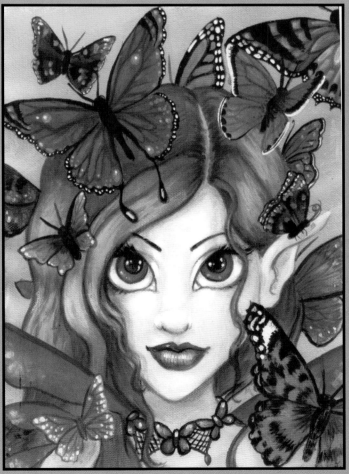

Butterfly Fairy.
By Ronne P. Barton.

Throughout history the origins of fairies has been hotly debated. Some people say they are a race entirely separate from all others, some say they are a type of spirit, literally ghosts of the dead, and they have been called both a type of angel and a type of demon. Notably, in European folklore, they can be driven off or warded against by brandishing iron at them, much like any other evil-minded magical creature. Many old stories say that there are both good and evil-minded fairies who are known as the Seelie, or Blessed Court, and the Unseelie, which is the Unholy Court. In the oldest stories of fairies, then called the peri, they were virtuous spirits who were hunted by demons and kept like birds in cages until they withered away to nothingness. In both Islamic tradition and Gaelic belief, fairies were part of the group of Angels that rebelled against Heaven and they repented too late to be forgiven or returned to Paradise.

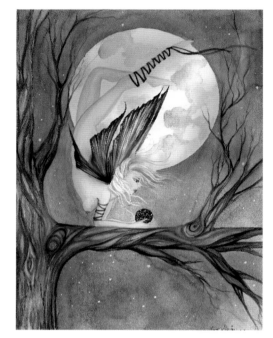

Tree Fairy. *By Heidi M. Drake.*

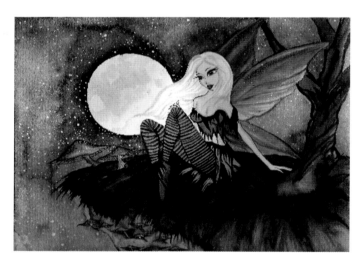

Magic Mushrooms. *By Heidi M Drake.*

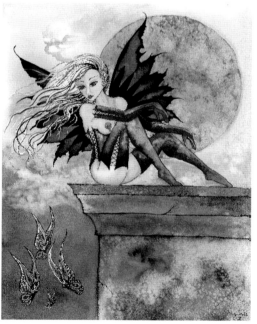

Sound of Wings.
By Heidi M. Drake.

60

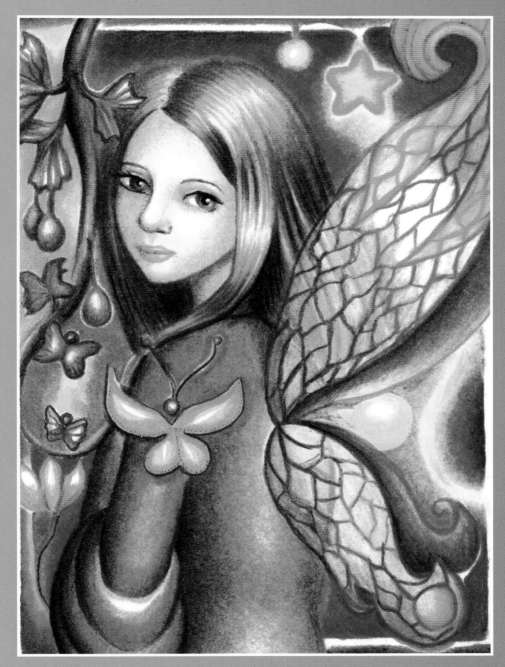

Winged Branches. *By Olga Ziskin*.

In Slavic tradition, fairies, called the vila, are thought to be the spirits of dead virgins or children. They leave their graves at night to dance and lure any human who happened to see them into the fairy ring they danced. Once a human had taken part in this dance they belonged to the fairy folk forever. Regardless of the theory of their origins dancing in fairy rings is attributed to fairies worldwide. A fairy ring is a naturally occurring ring of mushrooms, or even just a darker patch of grass in a meadow or forest. It is thought the circle is created from fairies riding stolen horses in a circle, or from their wild nightly dancing. Any human that steps into a fairy ring has very little chance of returning to his life unscathed. Sometimes the human participant will dance for what they think is one night, but upon returning home they find out that many, many years have passed. Their wives or husbands have grown old and died, their grandchildren have been born and grown, all in the space of the time it took for them to dance one night with the fairies. Sometimes the human dancers never make it home. They're forced to dance with the fairies forever, or dance until they drop dead from exhaustion.

Alessa. *By Nikki Burnette.*

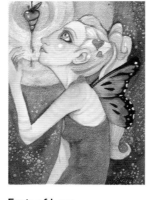

Fruit of Love.
By AGCOOK.

Celtic Fantasy. *By Denise Connell.*

One of the most disturbing stories associated with fairies is that of the changeling myths that are found throughout the world. There is a widespread belief that sometimes fairies steal human children and replace them with either one of their own children, or with a rag doll or piece of wood that has been animated. The switch is usually discovered very quickly because the changeling baby is ill tempered, oftentimes malformed, and sometimes has such a voracious appetite that it can never be satisfied no matter how much it is fed. If the child is replaced with a piece of wood or a toy, instead of a fairy baby, it generally dies very quickly. A fairy child changeling grows at a faster than average rate and grows more horrible the older it gets. No reason has ever been given why the fairies would want to steal babies, and leave monsters in their place, and one can only presume it is another example of their not very humorous jokes. There are several ways you could avoid having your baby snatched; you can repel the fairies by placing a small object of iron in the babies crib, and almost all cultures believed an un-baptized baby was more likely to be kidnapped. In German lore the fairies take only the children who are the most beautiful and attract attention and envy from others. Boys are taken more often than girls, and blonde blue-eyed babies are coveted by fairies most of all.

Fairy Dream. *By Denise Connell*.

Fairy in the Reeds. *By Maureen Craver.*

Sweet Fairy. *By Maureen Craver.*

There are some examples of human babies being returned to their parents. Sometimes this can be done as easily as exposing the changeling for what it is. The Brothers Grimm recorded many tales of changelings who were surprised into admitting their old age when they commented on the strange behavior of their adopted parents, such as when one wife brewed alcohol in an acorn, or when another cooked a whole meal inside the shell of an egg. Unfortunately, these stories are rare. It is much more commonly heard that you have to abuse or kill the changeling before your real child will be returned. The favorite method of this is by placing the changeling inside of an oven and cooking it alive until its fairy mother can stand it no more and comes back for him. Even these stories are the exception; folklore tells us that most often when a child is stolen it is gone forever, and no amount of abuse or trickery can ever bring it back home to its human parents.

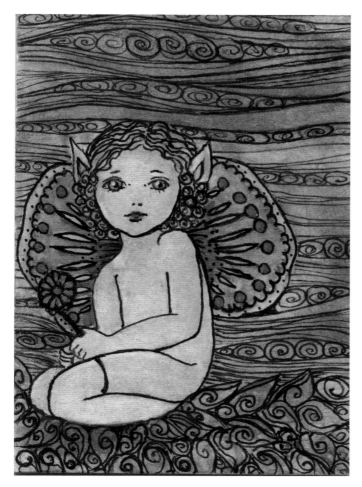

Green Eyed Fairy. *By Maureen Craver.*

be fierce hunters, and also givers of sage advice. Be warned though—if you make a comment about their diminutive size they will strike you down with tiny, though deadly poisonous, darts. According to tradition the first greeting you will get from an Abatwa is a question "From where did you see me?" It is in your best interest to tell them you saw them from far away, a mountaintop, or cliff ledge, belying their small size.

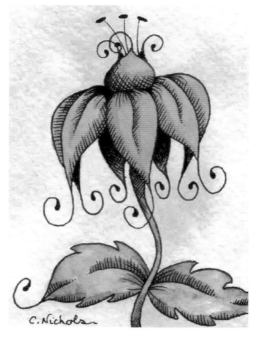

Fantasy Flower 12. *By Cris Nichols.*

There are as many fairies as you can imagine; flower fairies, rainbow sprites, enchanted animal fairies. There are as many fairies as there are places on the Earth. Like most fantasy creatures each culture sees them differently and puts their own unique spin on the myths.

In South African Zulu mythology, they tell tales of an exceptionally tiny race of Abatwa fairies. These fairies live in the same tunnels as ants do and generally shun the human race. Abatwa fairies will sometimes, though rarely, show themselves to men who have magical abilities, either a shaman or wizard. More often they are seen by young children under the age of four and pregnant women. It is a great honor for a pregnant woman to be visited by the Abatwa; if she is in the third month of her pregnancy, meeting the Abatwa guarantees that she will have a boy.

Some texts have said that the Abatwa are not fairies at all, but are really the smallest human race to ever walk the African savannah. They are said to

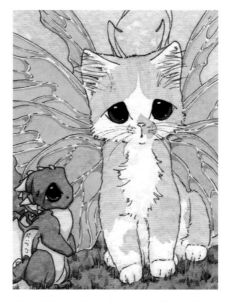

May I Have Your Attention Please?
By Misti Hope Wudtke.

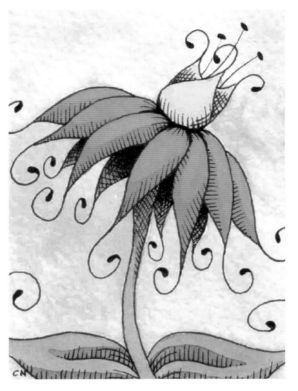

Orange Fantasy Flower. *By Cris Nichols.*

In Bolivia they tell of a race of fairies that are about as different from the tribal warrior Abatwa as you can get. These Acalica fairies are weather elementals that can control rain, hail, frost, and sleet. The live in deep underground caves and no one knows what they look like or how they live. On the rare occasions they come to the surface they wear the appearance of a grizzled, weak, little old man.

South America has the most unusual origin for their fairies, the bakru. The bakru are actually created by man, albeit ones well schooled in magic, to act as familiars for mages and priests. These fairies resemble small children and are sold by the pair at markets ... if you know the right places to look and have a lot of coin in your purse. The bakru are quite troublesome and nearly impossible to control. It takes a very powerful mage to keep them in line. Most shaman will tell you they just aren't worth the money you spend to buy them.

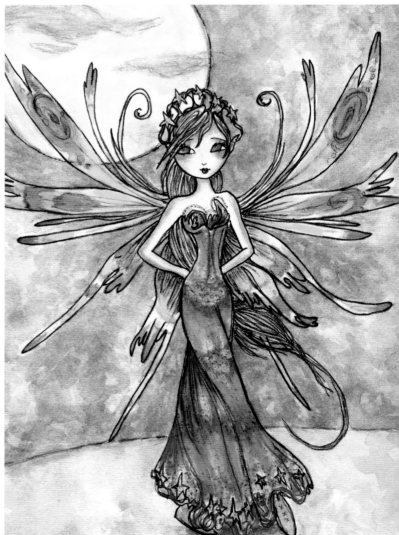

Moon Fairy. *By Lorelei Bleil.*

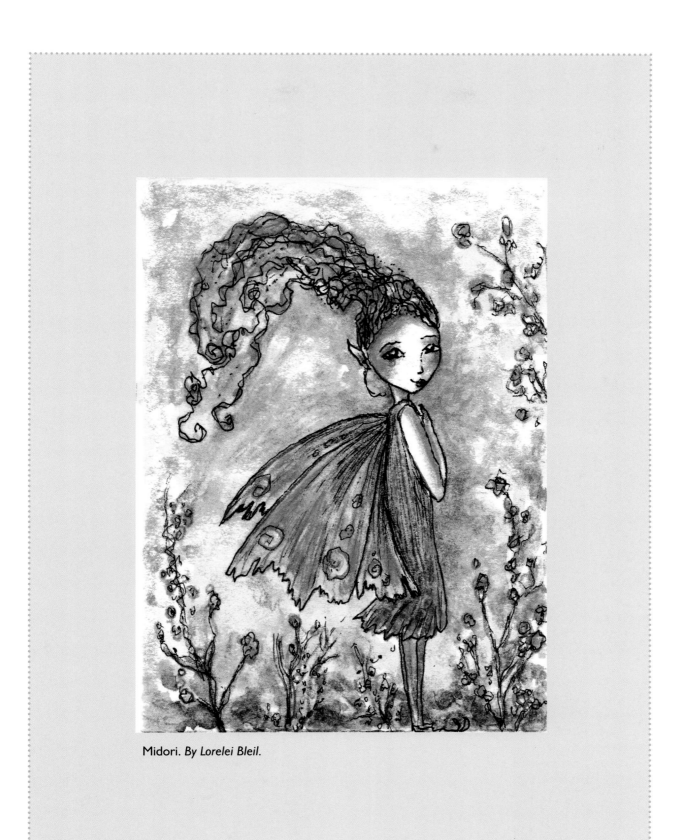

Midori. *By Lorelei Bleil.*

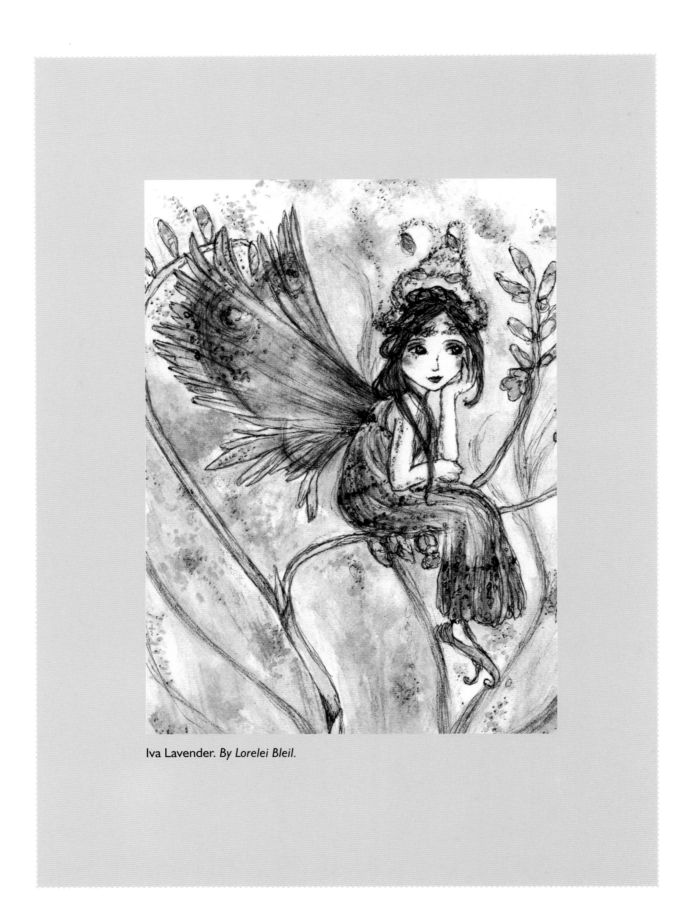

Iva Lavender. *By Lorelei Bleil.*

Spanish fairies, the aloja, have nothing to do with the forest. They are given a much grimmer job. More like the fates, than the small winged beings we think of as fairies, the aloja oversee the processes of life, death, and fate for the mortals of Earth. They watch each child being born, decide his path, and decide when it will end.

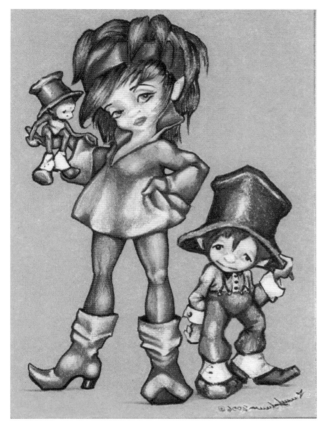

Jamie, Jinx and Jax. *By Susy Andrews.*

Leprechaun

A leprechaun is a male, Irish fairy that loves making mischief, and works as a shoemaker by trade. Leprechauns are the wealthiest of the fairy folk and keep piles of gold coins in black pots that they bury in hard to find locations such as at the end of rainbows.

The leprechaun is usually an older gentleman, dwarflike in stature, and usually red haired. He is quite the dandy, always appearing finely dressed usually in a green or red topcoat with a bright gold button. He is fond of velvet top hats and wears only the best made leather shoes.

According to legend you can trap a leprechaun just by staring him in the eye. The fairy will freeze and be unable to move, but if you so much as blink, or look away for the briefest of seconds the leprechaun will be freed and disappear.

Leprechauns are solitary creatures; they dislike others of their own kind, other fairy folk, and all humans. They are well spoken, polite, and quite cunning. When faced with a wily human, hungry for leprechaun gold, more often than not they can outwit the greedy fiend with little to no trouble.

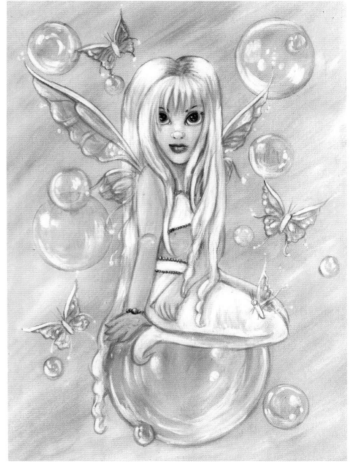

Butterflies and Bubbles-White. *By Ronne P. Barton.*

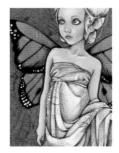

Fairy in Dress.
By AGCOOK.

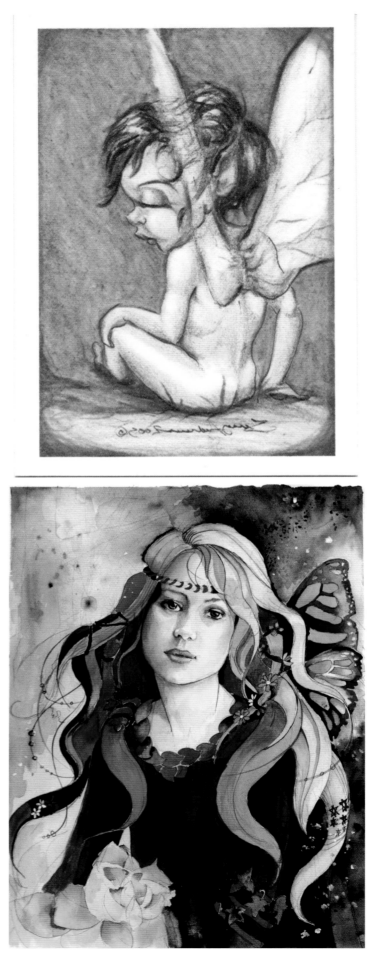

Ben. *By Suzy Andrews.*

Woodland Fairy.
By Denise Connell.

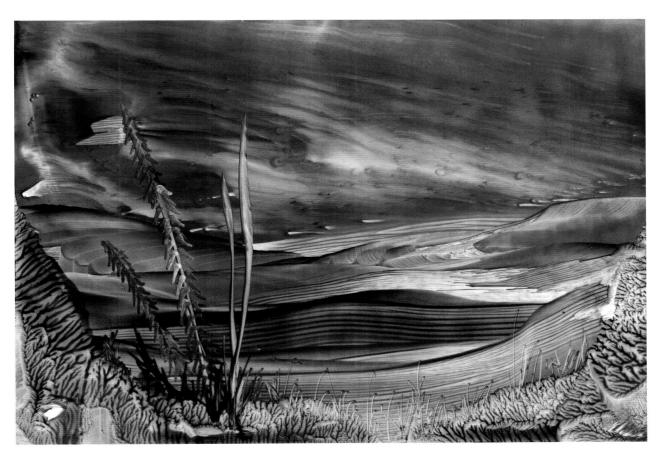

Foxgloves. *By Juliet Firstbrook.*

Nymphs

Nymphs are any one of thousands of female sprites that have a semi divine nature. They are usually known by where they live, such as a specific mountain, grove, forest, or spring or they are known for their affiliation with one God or another. In Greek mythology, nymphs attended to many of the Gods and Goddesses. The nymphs were also usually targets of the lustful centaurs and satyrs, being particular favorites of the goat God Pan.

The nymphs are not immortals, though they have lives that long outlast even the oldest of humans, and they retain their youth and beauty until they die. There are no old or ugly nymphs. They are usually seen cavorting around naked, or bathing each other in springs, and usually hang about in large groups. Sometimes the group of nymphs are family related, all being sisters or cousins. The landmark that the nymph is tied to often dictates their appearance. Water nymphs are sometimes shown as mermaids, or beautiful women with webbed fingers. Mountain nymphs are sturdier looking than their long lithe tree nymph cousins, the dryads.

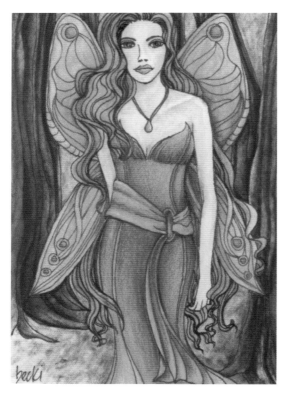

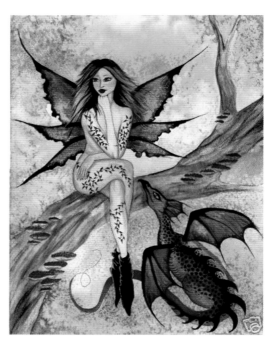

Cold Feet. *By Heidi M. Drake.*

Fairy of the Forest. *By becki bolton blackburn.*

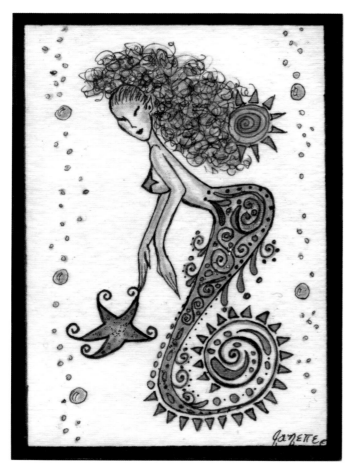

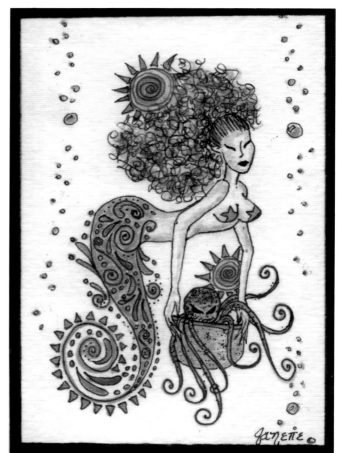

Water Sprite. *By Janette.*

Water Sprite 2. *By Janette.*

Nymphs have beautiful voices, and play all musical instruments. They are storytellers, lovers of art and music, who spend their days lounging and entertaining each other. They are well versed in the healing arts. They heal heroes hurt in battle, and offer a cool refreshing drink to lost travelers, but human encounters with nymphs are normally rare.

In Classical mythology there are hundreds of different classifications of nymphs, each one being broken into dozens of more specific groupings, all of which can end up numbering into the thousands since each rock, tree, stream, or pond usually has its own nymphs. There are the dryads, who are tree nymphs. Dryads can be broken down even further into specifics like the meliai, who are dryads of ash trees, or the epimeliad who are nymphs of apple trees. Each type of dryad has their own distinct personality traits; dephnaie, for example, are sleepy nymphs who only wake up when no one is around to bother them. Dryads are linked fully to their homes; they are a part of a specific tree in their genus. If the tree dies the dryad linked to that dryad dies as well.

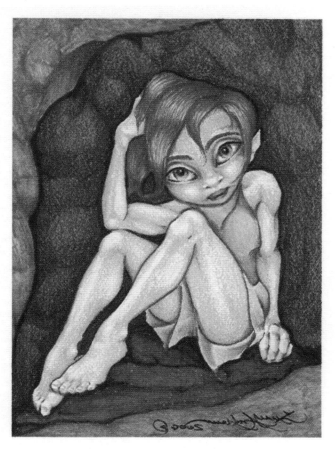

Forward Focus. *By Susy Andrews.*

Dryad Forest. *By Cindy Petersen.*

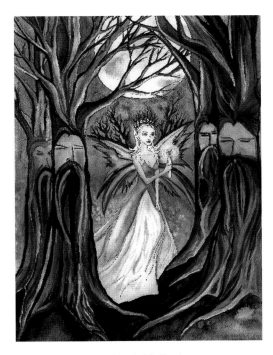

Fairy Princess. *By Heidi M. Drake.*

The three major classes of water nymphs are the oceanids (who were associated with any salty water), the naiads (fresh water), and the nereids (who were specific to the Mediterranean Sea) though almost all lakes, springs, fountain, marsh and streams have their own type of nymph. Oreads are mountain nymphs said to be the most wild and untamable of all the fairy folk. They were attendants of Artemis, the Goddess of the hunt. There were nymphs of the seasons and justice called the horae. There were nymphs of the seasons and justice called the horae. There are even nymphs of the underworld, the lampades, who carry torches for Hecate, the Goddess of witchcraft and of the crossroads, where, in ancient Greece, suicides were buried and travelers feared to walk at night. The Native American Iroquois believed in nymph-like creatures, which they separated into three separate tribes collectively known as the jogah. There were the nymphs of rocks and rivers known as the gahonga, the gandayah who protected the fecundity of the land, and the ohdows who protected the people of Earth from the monsters who dwelled underground.

Pixies

The name pixie is a modern invention, taken from the older word piskies. In modern mythology the word pixie is interchangeable with fairy or sprite and is no longer associated specifically with the classic piskies, warring red headed piskies of Cornwall.

Piskies are a very territorial race of fairy folk who inhabit the modern day lands of Devon, Cornwall, and Somerset. Piskies come in all different sizes, the smallest of which have wings and the largest of which are the height and stockiness of dwarves, but they all have red hair, pointy elfin ears, and an affinity for wearing green.

Piskies are the souls of un-baptized children and people who died before the coming of Christ. As they were never baptized they are unable to go to Heaven, but are not bad enough to be sent to Hell. Living the rest of eternity as a fairy is something like a Purgatory they can never hope to be released from.

Despite being considered a separate race of fair folk, the piskies are identical to fairies personality wise. They mislead travelers and steal horses, along with other assorted mischief. But the piskies have a more blood thirsty side than the average fairy. They hang any criminal who wanders into one of their fairy rings, as they detest dishonesty and baser human traits, and they feud with neighboring fairies. When one of these fairy races encroaches on piskie territory, a great war is waged, of which the piskies are always the clear-cut victors.

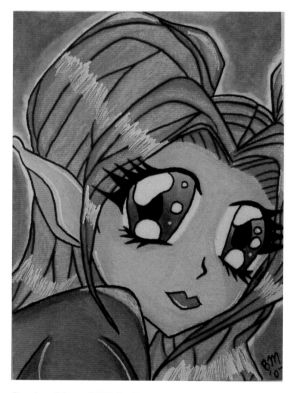

Scarlett Haired Elf. *By Brittany M. Brewster.*

Rose. *By Nikki Burnette.*

Tiny Sandman. *By Maria Van Bruggen-Elfies.*

Terrible Lizards

"It does not do to leave a live dragon out of
your calculations, if you live near him."
J.R.R. Tolkien

Many of our earliest stories have reptilian characters. By the same token many of the earliest Gods and Goddesses are either serpents or lizards. There has long been speculation that these worldwide reptile archetypes began when ancient people found dinosaur bones and had no other explanation for what they could be. Massive, tooth heavy skull found? Must be a dragon.

The word dinosaur is derived from the Greek and it means terrible lizard. But the creatures that humans built stories around after finding remains of dinosaurs are much more awful than anything nature ever created. Whether it be the Devil disguised as a serpent, and tempting Eve with forbidden fruit, or a dragon terrorizing a small medieval village, these stories all show man's long fascination with reptiles that are so alien to us, and yet live in all the same places that we do.

Basilisk

There is much debate about the appearance of the fearsome basilisk. In most texts it is said to be a snake like creature with small arms near its head, or at the very least a somewhat upright appearance. Basilisks get their name from the Greek word basiliskos, which translates to king, or little king. The name refers to the crest that looks vaguely crown like on the head of this venomous beast.

The reason for all the debate about its appearance is simple — the basilisk is such a single-handedly evil and poisonous creature that no one can see it and survive to tell the tale. Merely by looking at the basilisk the viewer is fatally poisoned, and just being seen by a basilisk results in a painful but almost instant death. Even if you somehow manage to not see, or be seen by the creature, its breath, bite, and venomous spit can all kill you. Even fruit rots from the trees as the basilisk passes, and its breath has been blamed for the barrenness of the Sahara Desert.

Big Dragon. *By Kris Kormish.*

Travelers, who worry they might be straying into the basilisk's territory, carry crystal globes and mirrors with them to reflect back the beasts stone glare. The basilisk is so completely horrific that looking at its own self is akin to suicide. Strangely enough the basilisk's most hated enemy is the common rooster, whose raucous cock-a-doodle-doo sends the fearsome serpent into convulsive, and even fatal, fits.

Oddly enough, in Iceland they believe in a creature that has exactly the same poisonous qualities as the basilisk, but looks like an ordinary bird. This creature, the skoffin, has been driven to extinction because its poison is so potent that its glance killed even its own kind.

Basilisk. *By Theresa Kenyon.*

Dragons

Whether called a mighty wurm, a drake, drakon, or dragoon, dragons have been an important part of the folklore and mythology from every known culture, going back as far as there were men to talk about them. There is little definitive in the world of dragons. Even the terms used to describe them are up for debate — for example; while the term drake is often interchangeable with dragon, other people will tell you a drake is a small, wingless, and sometimes non-magical dragon. Wurms may refer to dragons living underground or in water that are wingless and legless. Or wurm can simply mean dragon. For the most part if you can imagine it you can call it a dragon, one way or another. They are the ultimate reptiles — although varying with culture, and even time period, there are some dragon 'basics' you can expect no matter where you go. Typically dragons hatch from eggs, have large lizard or snake like bodies and usually breathe fire, although things like frost dragons or lightning dragons that can spew out those elements are a staple of modern mythology thanks to the popularity of role-playing games. Dragons are, typically, flying creatures even in the cultures that depict them as wingless. Dragon wings run the gamut from colorfully feathered, to green leathery appendages whose span can blot out the sun, to small bat like wings that can scarcely be imagined to lift a creature of that size. Sometimes dragons are shown with a barbed tail that is, like a scorpion's, an extremely poisonous weapon.

Purple Maned Dragon.
By Starla Olevia Friend.

Far from being a big dumb monster, many tales show dragons as intelligent creatures, ones who enjoy riddles, or otherwise trying to test the smarts of would be heroes. Dragons are usually workers of magic, and the blood and tears of dragons have magic properties of their own, though stories vary wildly on what this magic might be. In some they cure poison; in others they are poisonous. They can also grant unusual powers like the ability to always tell when someone is lying to you or to ability to understand the speech of animals.

Blue Eyed Dragon. *By Nina Bolen.*

Bronze by Night. *By Misti Hope Wudtke.*

#30. *By Kris Kormish.*

#23. *By Kris Kormish.*

Are you my mom? *By Misti Hope Wudtke.*

77

Dragons are treasure guardians and gold hoarders. Some tales even say that they eat precious metals like gold and silver, and snack on gemstones! Dragons are often charged with guarding the most unusual and irreplaceable items. For example, in classical Greek mythology, it was a one hundred headed dragon that guarded the immortality granting golden apples of the Hesperides.

While dragons are generally thought of as mere guards, or hoarders of treasure, some cultures give them much more illustrious jobs. In Mexico their most famous dragon, Campacti, created the world from his own slain body. The dragons Rou Shou and Gou Mang, from Chinese mythology, are messengers to the sky God. Gou Mang brings the spring and good tiding, but Rou Shou heralds the coming of autumn and ill news. The Chinese also have four powerful dragon kings: Ao Kuang, Ao Chin, Ao Ping, and Ao Shun. They are God like creatures that rule over the seas. The dragon kings, while dragons in their natural form, are also shape shifters who like to walk the Earth as humans. They live in decadent underwater crystal palaces and are attended to by fish and crustaceans. The dragon kings had magical pearls of wisdom they keep safe in their mouths and rule not just the seas, but the rain and storms as well. When angered they can flood entire cities, or scour them from the land completely. They are the most famous of China's many dragon Gods that also includes Ryujin, a dragon that lives at the bottom of the sea and controls the tides by sucking water in and out of his massive mouth.

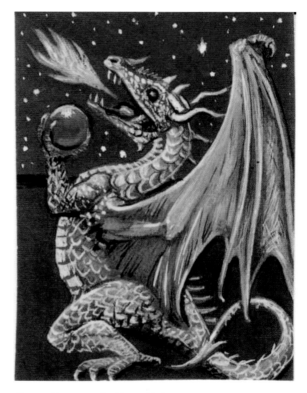

Green Dragon. *By Kerry Nelson.*

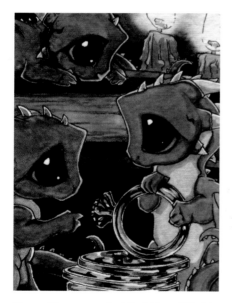

Pretty Treasures. *By Misti Hope Wudtke.*

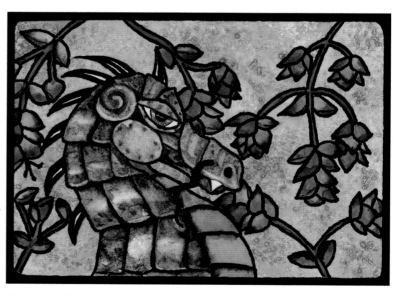

Marjoram. *By Cara Brown.*

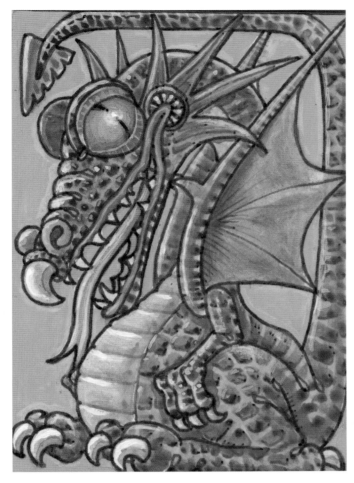

Dragon. *By Michael Ramirez.*

of life and death; Koshchei, both a demon and a dragon, gained his nickname because he was next to impossible to kill. The clever dragon Koshchei hid his soul in an egg that was then hidden inside of a duck, which was then hidden inside a rabbit. The rabbit/duck/egg was then placed on a remote island. The hero, Bulat the Brave, eventually defeated Koshchei, finding the egg with the help of a beautiful princess whom Koshchei had kidnapped, and breaking it over the top of the dragons head, killing him instantly and nullifying his terrifying moniker.

Dragons could also foretell the future, or danger, as in the case of the o goncho, a white winged dragon from Japan. Periodically the o goncho will transform into a golden bird, with the heart-breaking cry like the howl of a wolf. Hearing the dragon-birds cry is a warning of eminent disaster.

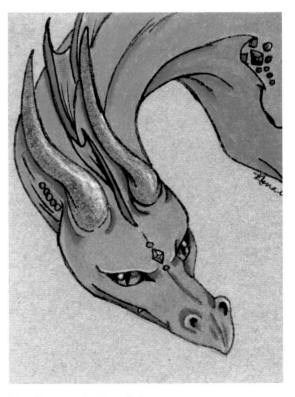

Blue Dragon. *By Nina Bolen.*

Perhaps because dragons often live in underground caves many cultures connect them with the underworld and death. The Indonesian dragon Anamtaboga is the ruler of the land of the dead. Norse mythology has an actual dragon of death, Nidhoggr, who, vampire like, drinks human blood and eats the rotting flesh of corpses and chews endlessly at the roots of Yggdrasil, the world tree. Meanwhile, Russia's Chudo-Yudo, a many headed dragon and sibling to Koshchei the Deathless, controls the waters

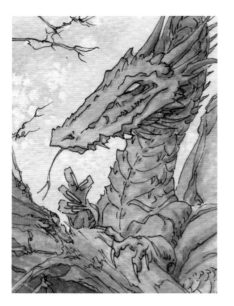

Up to No Good. *By Misti Hope Wudtke.*

It is also long associated with dragons that they make demands for young girls or virgins to be delivered to them once a month, or once a year. If not satiated with a suitable woman in the manner they demand, the dragon will terrorize the village, killing humans and livestock and blighting the farmlands. In particular there is the Albanian bolla, a dragonesque silver eyed snake that sleeps for twelve years, awakening just once a year on Saint Georges Day to feed on humans. At the end of its twelve-year cycle the bolla becomes Kulshedra, a horned nine-tongued fire-breathing dragon that controls the rains. If not given a sufficient number of young girls to snack upon, kulshedra causes droughts that destroy whole villages.

Golden Dragon Baby. *By Nina Bolen.*

Waking Bolla. *By Elizabeth D. Cummings Johnson.*

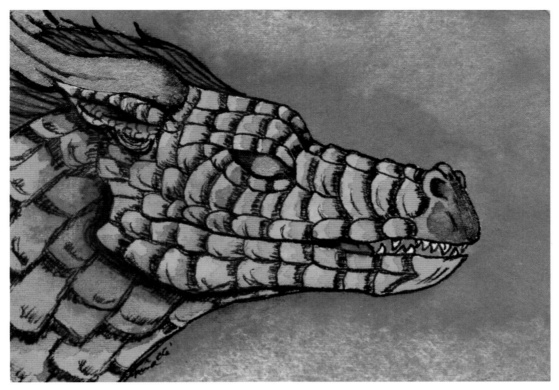

Fire Drake. *By Nina Bolen.*

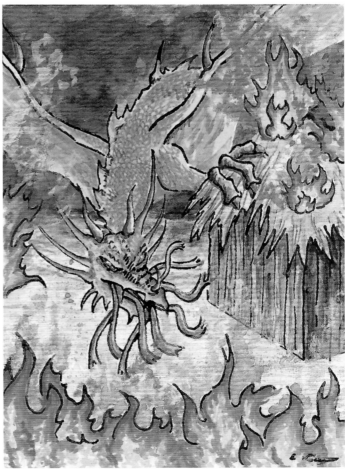

Kulshedras Wrath. *By Elizabeth D. Cummings Johnson.*

Of course, all the talk about helpless maidens in distress, and most especially the tales of treasure, have spawned a host of stories dealing with Gods, heroes, or otherwise courageous beings who quest for, then battle, an enraged dragon to take its treasure. These stories date back to the very earliest of times; there are versions of these stories surviving from Mesopotamia and Babylon.

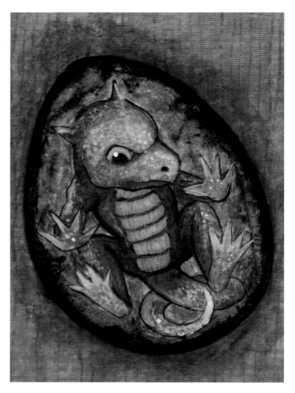

Frustration. *By Starla Olevia Friend.*

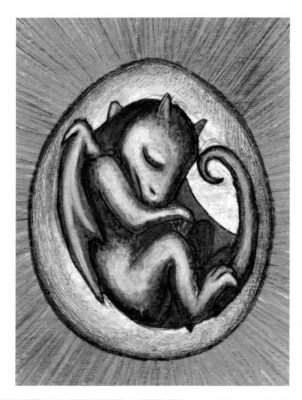

Waiting to Hatch.
By Starla Olevia Friend.

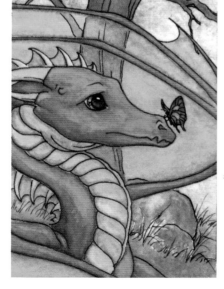

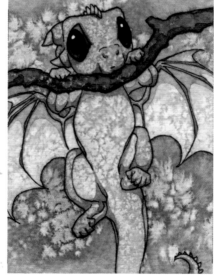

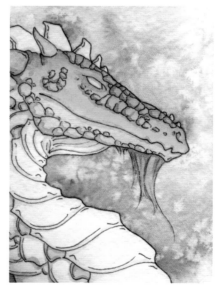

That Tickles. *By Misti Hope Wudtke.* Hanging Around. *By Misti Hope Wudtke.* Flame. *By Misti Hope Wudtke.*

The dragon is especially revered in Asian cultures, were they are seen as more snake like, and closer to divinity, than their European brethren. They have a long serpent's body, with talon edged legs at the extreme front and back, and an oversized head, sometimes with a ruff of feathers or scales making it look even more massive. Sometimes these dragons are depicted with small wings set near their shoulders.

In China, along with many other places, dragons are associated with water — even fire breathing ones! Chinese myths also often draw a connection between carp and dragons, some stories saying that the fish can turn into a fearsome dragon at will, while others say that the carp are a juvenile form of the massive reptiles. When the carp reach a certain size and age they jump up from the depths of the ocean, unfurl their wings, and take flight as dragons. It is also common in many cultures for dragons to live underwater

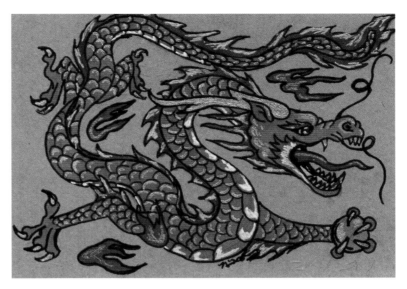

Asian Dragon. *By Nina Bolen.*

rather than in caves as is said in European stories. The Irish have a spike covered sea dragon so horrible that, like the basilisk, can kill someone merely by being seen by them.

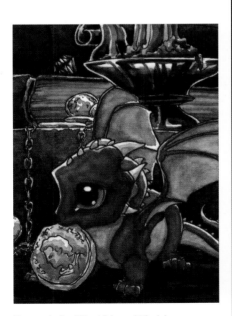

Busted. *By Misti Hope Wudtke.*

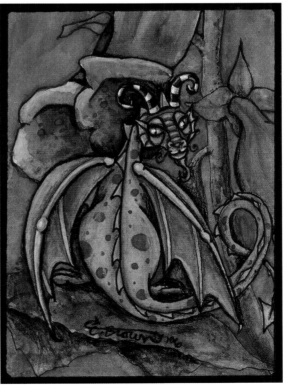

Foxglove Dragon. *By Christi Brown.*

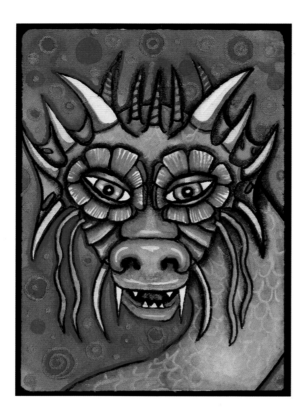

Graygon. *By Cara Brown.*

Some of our oldest stories about dragons come to us from the ancient Sumerians and Babylonians. To them the first creatures to form after the creation of Heaven and Earth were two dragons, Abzu and Tiamet. Together they spawned a host of Gods. But the Gods were evil and the two dragons bickered constantly over what should be done about them. After the death of Abzu at the hands of these unruly divinities Tiamet swore revenge and created eleven monsters. However the God, Marduk, defeated all eleven; then he slayed her and used parts of her body to create the cosmos.

Hindu tradition also has a story about a dragon intermixing with the Gods. Rahu was a demon with a human's body and a dragon's head and tail that came, uninvited, to a festival where the Gods were drinking the immortality giving nectar called amrita. Rahu managed to take a sip of the drink before Vishnu beheaded the monster. His dragon-like head flew up into the sky where it now chases the moon, taking a bite from it periodically.

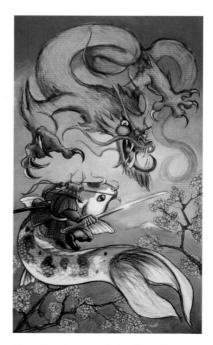

The First Battle of the First Day.
By David Ferreira.

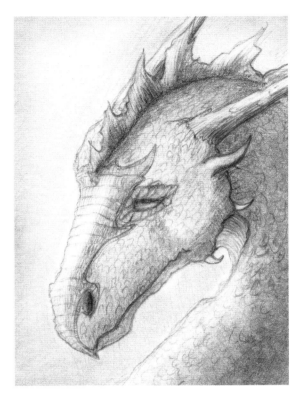

Kiyo, the most fearsome fire breathing dragon in Japan, also traces its roots back to unrequited love. As a serving girl in a small tearoom, she fell in love with a young monk, who, despite his vows, began to court her. But the monk couldn't escape his guilt over breaking his vows and finally he abandoned the serving girl and returned to the monastery. The scorned serving girl decided it was time for payback. She began to study magic and practice black arts, eventually turning herself into a dragon. In dragon form the serving girl flew to the monastery where her former lover was hiding and killed him. As her punishment she was forced to remain in dragon form for eternity.

Dragon, Eyes Closed. *By Starla Olevia Friend.*

The rarest stories about dragons involve a human, usually a scorned young girl, transforming into a dragon, rather than the dragon just being born that way. We get the following story from Malaysian folklore.

Tioman was once a beautiful princess who desperately loved the son of a nearby King. The son though already loved another woman and never even noticed Tioman's adoration. The poor princess was so heartbroken over her unrequited love she could think of nothing but evil thoughts of revenge. In time her outward appearance turned into that of a dragon to match her envious, black heart inside. Sadly, Tioman would never return to human form. She was so horrified at what she had become she fled to the South China Sea. After many years of gazing into the waters at her dragon form she changed shape for the last time, this time into the island Pulau Tioman, best known from the musical South Pacific. Now, in island form, her good nature has returned and time has healed her broken heart. Tioman has sworn to shelter and comfort all travelers who wander onto the island.

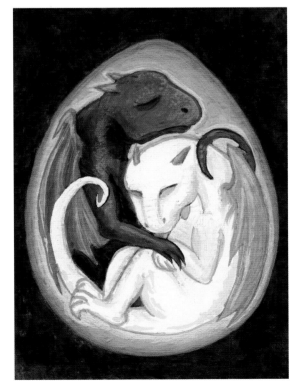

Dragon Twins. *By Starla Olevia Friend.*

But these are very unusual dragon tales. In many places dragons were seen as commonplace, every day, and sometimes down right boring. The Estonians believe that every household had its own dragon guardian called a pisuhand, or pukis. This species of dragon takes the form of a house cat on the ground but in the air they have snaky dragon bodies, just a few feet in length. It's hard to imagine that they scare away much danger considering their diminutive size but they, like most dragons, have an insatiable need for treasure. This adds greatly to the fortunes of the family they guard, but makes them very unpopular with the neighbors, who most of the stolen treasure comes from.

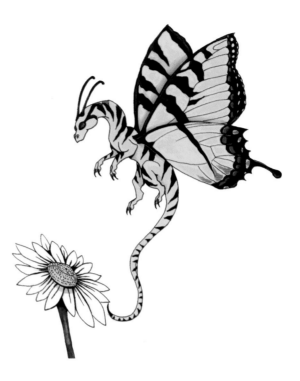

Dragon Fairy. *By Nina Bolen.*

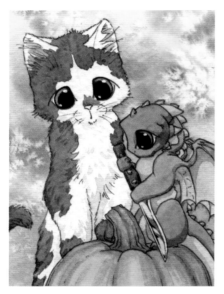

Carving Time. *By Misti Hope Wudtke.*

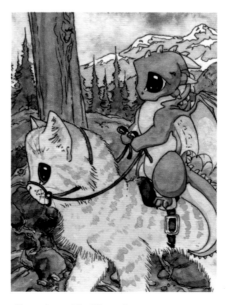

Caparison My Kitten!
By Misti Hope Wudtke.

They are usually much larger than even the biggest dragon, and, like rocs, they feed whole elephants to their young. A close relative of the wyvern is the sea-wyvern, which has a fish's tale and terrorizes the creatures of the sea.

Wyvern

From midlevel Europe we get this dragonesque creature, the wyvern. Its name comes to us, via the French wiver, which is derived from the Latin vpera meaning viper. It is a beast with a classic dragon's head, the body of a snake, and bats' wings, with two small legs on the upper half of its body. Sometimes the wyvern is shown with a poisonous barbed tail, or even the back half of a scorpion. The wyvern differs from dragons in that it has always been associated with the most evil of human traits like greed, spite, envy, and war. There are no God wyverns, or well-regarded wyverns. Some texts describe the wyvern as being a cousin more closely related to a basilisk then a dragon due to its decidedly evil nature. They are unintelligent creatures – though not without low animal cunning – that causes disease and plague wherever they go.

The Wyvern's Egg. *By Teresa Coville*.

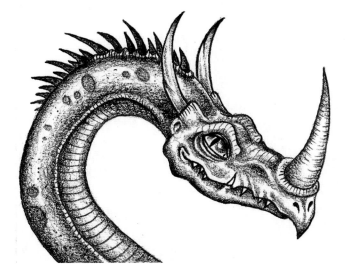

#25. *By Kris Kormish*.

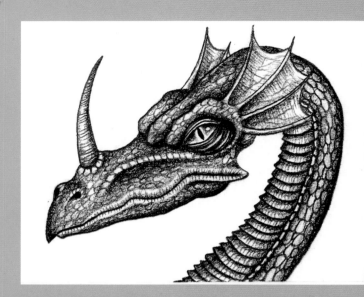

#29. By Kris Kormish.

Wyvern Beginning to Hatch. *By Teresa Coville.*

A Horse of a Different Color

"A wise man never plays leapfrog with a unicorn."
Tibetan Proverb

Snowflake. *By Misti Hope Wudtke.*

Horses were the lifeblood of people in the ancient days. If you had a horse you had something you could trade or sell, you had an animal that would help you work around the farm or lug rocks to build the farm, you had mobility, and if times got tough enough, you had something to eat.

There have been many religious sects that worshipped horses and cults that worshipped horse goddesses. In Europe there are even old traditions, known as 'hobby horse dances', where revelers would mimic the dance and energy of wild horses to encourage the growing season to be fruitful.

So it should probably come as no surprise that many myths center around horses and that back in the day people spent their time dreaming up all kinds of wild variations of the horses that meant so much to their way of life.

Centaur

In many ways the centaur is the ultimate mythological horse since it combines the equine in all its glory with humans. Centaurs are best known from Greek or Roman myths, though as you'll see, many cultures have tales populated by centaur like creatures. The centaurs are a race of half horse/half humans. Centaurs possess the legs, flanks, and hooves of the horse; and the torso, arms, and head of a human. Although the classic centaur has the bottom half of a simple horse, they have been depicted with the lower half of all kinds of horse like creatures, including zebras and gazelles.

They are close relatives to the Greek ipopodes, who are almost entirely human except for their equinoius legs

The Centaur. *By Molly Zirofax Rodman.*

and hoofed feet. In most myths both the centaurs and ipopodes are wild untamable beasts living in the deepest part of the forests or the unsettled mountains. They have a taste for wine and song, and a lust for all the sensual desires of the flesh.

Ironically, probably the best known of the centaurs is Cheiron, who had great wisdom and restraint. Cherien, or Chiron, lived inside a cave on the slopes of Mount Pelion, and was a great mentor to many of the Grecian heroes. Cheiron was so highly spoken of that, at times, even the great Gods and Goddesses would come to him for advice.

Sadly the gentle Cheiron would be done in by the ill reputation of centaurs. While Hercules was adventuring he came across a centaur by the name of Pholos who offered him a jar to drink from. Unbeknownst to the two the jar contained divine wine and the heady scent of it drew centaurs from miles around to the

clearing where Hercules rested. The centaurs fell into a drunken brawl and, fueled by alcohol, began to fight with Hercules. Hercules pulled forth his bow and arrows, which were smeared with the deadly poison from the monster Hydra, and drove the centaurs off. One of the arrows hit the gentle Cheiron, who was trying to calm down the fighting, and while it could not kill him since Cheiron was an immortal creature, it caused him unspeakable agony for the rest of eternity.

Some time later when Hercules laboured (sic) to free Prometheus from the tortures of the Grecian underworld, which was his punishment for giving fire to the people of Earth, Cheiron offered to give his immortality to Prometheus. Cheiron would get the death, and respite from his pain, that he had yearned for and Prometheus would be free from suffering. The Gods allowed the trade, and then took pity on noble Cheiron. Instead of putting him in Prometheus's place in Hades, they placed him in the sky.

Hindu tradition has two centaur like creatures, the gandarvas and the less likeable kimpurushas. The gandarvas wears beautiful smelling garments and guards the sacred life restoring drink, soma. They are superb musicians and are invoked at weddings to liven up the festivities. The gandarvas also have their own version of the knowledgeable Cheiron. They were led by Chitra-Ratha who, like Cheiron, is accredited with having brought medicine and the arts to humanity. The kimpurushas on the other hand are followers of, and servants, to a frightening demon.

Nickers are the Scandinavian version of centaurs; though they are similar in looks to other centaurs, they vary wildly otherwise. The knickers live in streams or lakes, and enjoy art and music like their Greek cousins. The knickers however are closer in spirit to water horses. Any human that tries to mount them will be stolen away beneath the waves to drown.

It's interesting to note that along with the introduction of horses to the New World by Spanish conquistadors, came a spontaneous resurrection of centaur stories, this time among the Native American population who had never before seen a horse. Upon first seeing the Spanish explorers on horseback many of the Native Americans mistook them for people possessing the bottom half of a horse.

Horses of the Sun

In mythology, no matter where in the world you are, horses are somehow inexplicably linked to either the sun or Sun Gods. Almost all cultures have stories of Sun horses, horses that pull or drive the sun across the sky from dawn to dusk. Sun horses also pull the chariots of sun Gods. They are pure white horses, and usually they have great-feathered wings.

Pegasus 1 - Celestial Ascent. *By Kerry Nelson.*

Kirin

Kirin. *By Nina Bolen.*

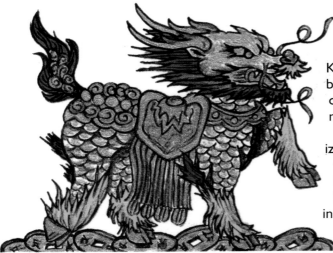

The Japanese kirin is something of a dragon unicorn hybrid, and yet is so different from both of those creatures as to earn it its own placement among the ranks of our mythological beasts. The kirin has the head and upper body of a dragon, and the body of a stag with a shaggy lion's mane. The female of the species is hornless while the males may have one, or several, horns jutting from their heads. Kirin's appear in a range of colors, most often red, black, or green. They are sometimes shown almost completely covered in thick scales, or with scales mixed throughout its fur.

Unlike the fiery dragon, and more like our idealized idea of a unicorn, the kirin is a pure creature that represents the five virtues and is the perfect balance between male and female, much like a living yin-yang symbol. The peace loving kirin lives in paradise and only comes to Earth at the birth of a great philosopher or gifted leader. It is the living embodiment of wisdom.

The kirin is so noble and gentle that, when passing by, it does not even bend a blade of grass with its hoofed feet. It will only visit countries with the fairest and wisest of leaders. It is a great honor to see one as it foretells that good fortune is coming. But kirins are also justice dealers that travel the land and punish the wicked. When enraged they can spit fire. A kirin has the ability to always know when someone is lying to it, and they understand all languages of man perfectly.

In China the creature is known as ky-lin, or qi-lin, and sometimes is shown with a massive rack of antlers like a stag. Sometimes the creature also appears covered in a flaming blaze that neither burns nor harms it.

Kirin Art Trading Card. *By Nina Bolen.*

Pegasus

To be precise Pegasus was the name given to a specific animal in Greek mythology. Pegasus is a great white, winged flying horse that sprung from the sea foam when the blood of Medusa fell into the waves after Perseus beheaded her.

Pegasus III - Fly with Eagles. *By Kerry Nelson.*

Pegasus was raised by the Muses. He is credited with having created at least two sacred wells by stamping his foot in the ground until it cracked open and water poured forth. Drinking from these springs would grant any human with the gift of poetry.

When the hero Bellerophon went to destroy the chimera he rode into battle on Pegasus's back. Bellerophon was able to tame Pegasus with the help of a golden bridle that was a gift from Athena. But Bellerophon soon lost the favor of the Gods when he started to think of himself as one of them. In return for his pride Zeus sent a gadfly to sting Pegasus. The horse reared, Bellerophon fell to the ground, and landed in a thorn bush. For the rest of his days Bellerophon would walk the Earth blind, limping, and shunned.

Pegasus was a messenger for the Gods, flying between Mount Olympus and the Earth on their errands. He is a sweet natured horse that takes joy in his flight.

However specific the name Pegasus used to be, in our modern mythology, Pegasus has come to refer to any winged horse. The divine flying horse of the Hindu, Poqhiraj, is a Pegasus.

Tipaka is a winged horse from Thailand. Tipaka was horse, and messenger, to King Sison, and for good cause. This horse is so fast that it arrives at its destination before its rider can even finish saying the name of the place it is to go!

Pegasus.
By Misti Hope Wudtke.

Pegasus II - Untamed! *By Kerry Nelson.*

Pegasus. *By Theresa Kenyon.*

Goat Girl. *By Jamie Fales.*

Satyr

Satyrs are closely related to centaurs. Instead of being half horse/half man, they are half goat/half man. Despite this they are, personality wise, quite identical to their horsy cousins — that is to say they have a love of women, wine, and music. Our word 'satire' is derived from the word satyr, because in early plays the most humorous scenes were played by actors dressed as goats. However satyrs have their more useful side as well. They help farmers herd their livestock, and they follow travelers at night to keep watch over them. But before and above all else they are forest creatures, and protectors of the woods.

Of course the most famous of the satyrs is Pan, the goat God, who watches over the shepherds and their flocks of sheep. Many stories tell of Pan's seduction of numerous nymphs, but he is also a patron of the arts. The rustic instrument that are called the panpipes stem from a myth about Pan, and 'the girl who got away', Syrinx. This nymph, rather than be ravished by the goat god Pan, turned herself into river reeds, and as the wind played over them, they sang a mournful tune. In honor of her Pan gathered the reeds together and created his signature instrument.

But Pan is not the oldest of the satyrs. That title goes to Silenus, a satyr who is an attendant to Dionysus, the God of wine. Silenus is much prized as an advisor as he cannot only clearly see the future, but he also has the rare ability to correctly interpret the past. Silenus is not shown as a satyr all of the time because the very oldest stories of satyrs say they are not goat men at all, but instead average men with a goat's tail. Their full evolution to half goats did not occur until during the Roman Empire. To deal with this difference some scholars have declared that Silenus is actually the only remaining survivor of an extinct race of selini, horse or goat-tailed men who sometimes had the ears of an ass and nubs of horns on their foreheads.

The Scottish version of satyrs is called the urisk. They are much more fairy like than their Greek and Roman cousins and often approach humans.

Unicorn

Is there anything more iconic than the pure white unicorn? Unicorns are normally seen as large, gorgeous, white horses with a spiraling single horn jutting upwards towards the sky from their foreheads. The unicorn is the protector of the forest, an unimaginably wild creature, who is near divine. Ancient lore says that only a virgin girl can ever touch or come close to the unicorn. The horn of the unicorn, and sometimes its blood, has healing properties, among them the ability to neutralize poisons.

Chasing the Light. *By Misti Hope Wudtke.*

Mini Unicorn Gold. *By Sonya Fedotowsky.*

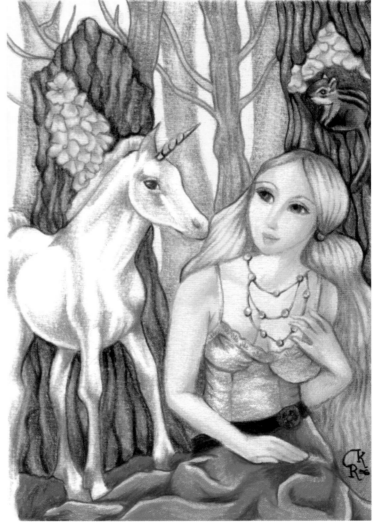

In ancient times there was no question among scholars that unicorns were a very real creature — not the product of myth or legend. Many of the Royal courts, the Tudor dynasty in England in particular, drank from cups made from a 'unicorn's horn' to dispel the possibility of assassination by poison. Many charlatans did brisk trade in unicorn parts for most of recorded history.

Young Girl with Unicorn. *By Roselle Kaes.*

The ancient Greeks believed that unicorns ran rampant in India, a place that, to them, was near mythological anyway. This is rather ironic because the Indian versions of unicorns are quite different than the beast that the Greeks thought flourished there. In India the creature is either called the catazonon or the karkadann. As the catazonon the unicorn has a fearsome reddish-yellow coat with a pure black horn and mane. The catazonon is so wild and untamable that it will put itself into a suicidal frenzy before ever allowing itself to be captured by men. The karkadann is an equally disturbing variation of the unicorn. While white in color, as we picture the unicorn today, it is bigger than a rhinoceros, has the tail of a lion, and two or three hooves on each foot. The horn of the karkadann is pure black. It hunts elephants for sport and can only be calmed by the singing of birds. The karkadann enjoys birdsong so much it has became a protector of them and it goes to extreme lengths to make sure birds' nests are not disturbed.

Veteran. *By Kerry Nelson.*

Palomino. *By Misti Hope Wudtke.*

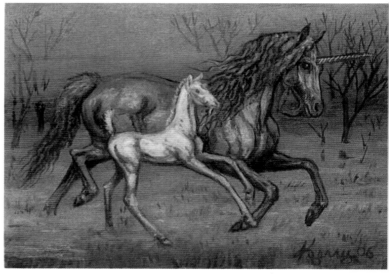

Out of the Mists. *By Kerry Nelson.*

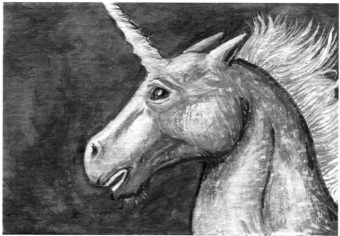

Unicorn Red.
By Starla Olevia Friend.

In Tibet they also believe in the wildness of the unicorn that they call tsopo. Their version of the creature is as chaotic and savage as South Africa's version of this creature, which they refer to as the ndzoodzoo. Overall, despite the prevalence of the pure gentle unicorn, most cultures see the beast as a wild thing.

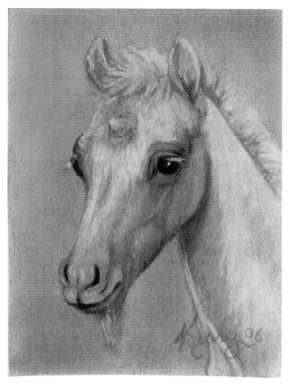

Young Unicorn. *By Kerry Nelson.*

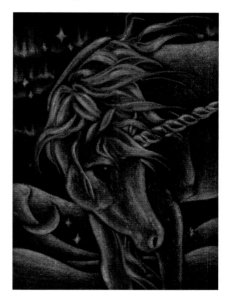

Purple Unicorn. *By Misti Hope Wudtke.*

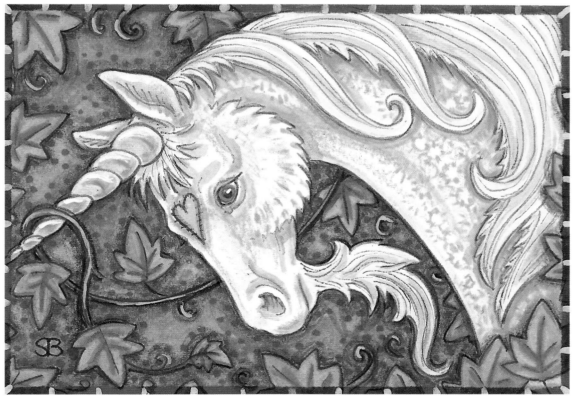

Pure of Heart. *By Susan Brack.*

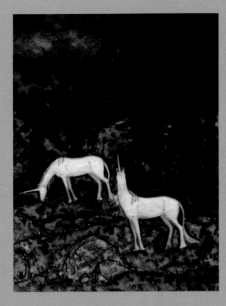

Calm before the Storm.
By Misti Hope Wudtke.

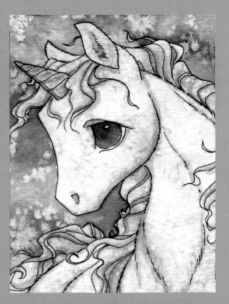

Innocence. *By Misti Hope Wudtke.*

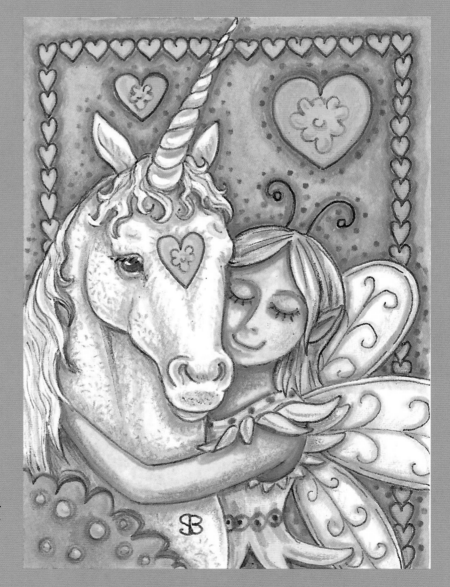

Kindred Spirit.
By Susan Brack.

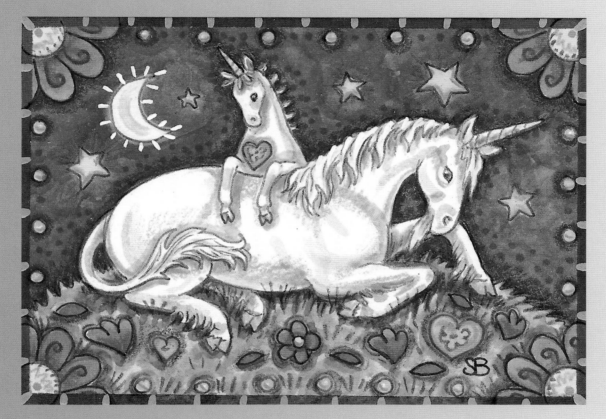

Unicorn Hill. *By Susan Brack.*

Water Horses

Water horses have darker appetites and blacker natures then the awe-inspiring sun horses. The stories about them run from the grim and to the frightening.

The uisge is a monstrous water horse from Scotland and Ireland, but it is pretty typical of the water horse stories told worldwide. The uisge appears as a beautiful horse or pony along the banks of large lakes. Anyone who tries to mount the each uisge will find they can't dismount. The horse then plunges them into the depths of the lake and eats them.

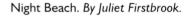
Night Beach. *By Juliet Firstbrook.*

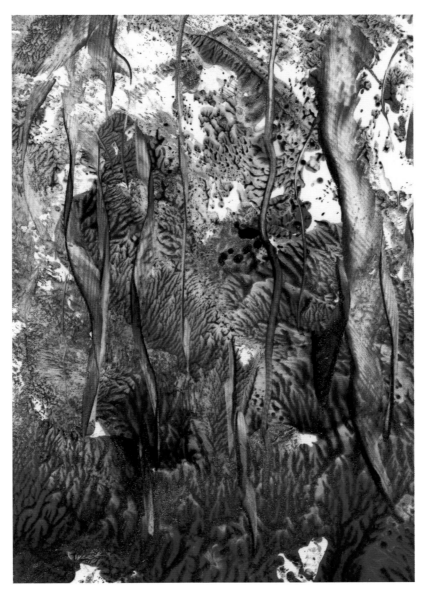

Under the Sea. *By Juliet Firstbrook.*

Yakshini

Other notable water horses of this nature include India's jala-turga, the French chevel bayard, the Scandinavian backahast, the Scottish biast na srognig, which is the only known cannibal unicorn water horse. There is also the buckland shag, which trampled victims to death in Devon, England, and was later banished by the Vicar of Buckland who was armed with the traditional bell, book, and candle of exorcisms. The Isle of Man has the cabyll-uisge whose food of choice is cattle, but who will also take the time to shape shift and lure young maidens away. The ceffyl dwr of North Wales has an unearthly glow and turns to a scum of algae floating atop the water when it is defeated. It is also known as the tangie in the Shetland Islands, where it appears to be covered in seaweed.

To the Hindus yakshini were a type of forest spirit and in art they are shown simply as beautiful women. There are statues of the yakshini that stand outside of temples beckoning people inside to worship. However the natural form of these creatures is that of a shapely young woman who has the head of a horse.

Having a similar story are the Hindu kinarras. They too are horse headed humans, and seem to be the male version of the yakshini. They are amazing musicians who were in the employ of Gods as merry makers.

Earth Movers

"A dwarf standing on the shoulders of a giant
may see further then the giant himself."
Robert Burton

Now for the movers and shakers of the ranks of mythology — literally! These are the creatures of the Earth that move the Earth, whether it's from their enormous size, or because they dwell below ground mining and tunneling, or in the case of our sod headed golems, because they are made the Earth itself.

You'll find that most of our Earthmovers are decidedly man like, one way or another, because the land is the element that people probably most associated with them. They walk upright, on two legs, and have humanoid features, give or take a few elements here or there. Many of these creatures could be considered as the first comic book characters; they are human ... and then some. They show that the idea of a superhuman, whether that means a human with added strength, magical abilities, or just extraordinary useful talents like the ability to hunt down good veins of gems, has always fascinated and entertained.

Cyclops

The word Cyclops, in and of itself, refers to a very specific group of giants from Greek mythology. They differ from traditional giants in that they have but one eye that sits in the middle of their forehead. There are two references to Cyclops in Greek mythology; one is that the Cyclops were the sons of Gaia and Uranus, who were predecessors to the Gods themselves. Zeus freed the Cyclops from Tartarus, a deep pit located below Hell,

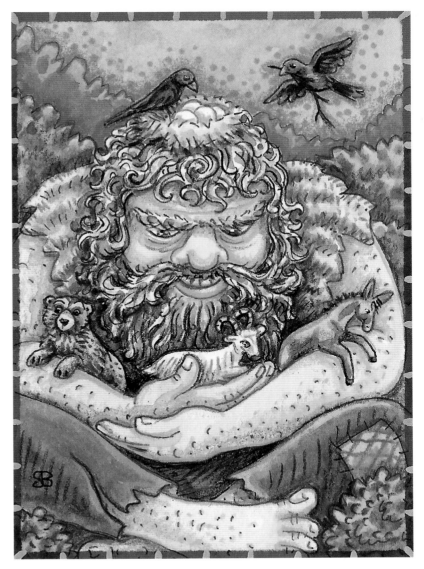

Gentle Giant. *By Susan Brack.*

and in gratitude they presented Zeus with his mighty weapon, the thunderbolt. Later on, in the *Odyssey*, Homer says that Cyclops are a race of their own, unrelated to the Gods, living on a distant island.

In our modern mythology the term 'Cyclops' has come to refer to any one-eyed giant, Greek or otherwise, though like all of our creatures the Cyclops are not unique to the Greeks alone. They are the i-mu kuo yan to the Chinese. In Armenia they have a similar group of Cyclops creatures called the dev, which are a race of primordial giants, each with seven heads, and each of the seven heads has one eye in the middle of its forehead. The dev are like giants in that they are mainly big dumb oafs, easy to outwit, who spend their time flinging boulders at each other for sport. Strangely the Armenians also believe that these cretins were shape shifters that spent much of their time in the form of snakes.

For whatever reason shape shifting has long been associated with Cyclops, though we don't think of it as one of their attributes today. On top of the serpentine Cyclops of Armenia, the Spanish version of this creature, tartaro, can turn into any animal they want. However the tartaro haven't perfected their shape shifting abilities. You can usually spot a tartaro hidden in animal form because of how misshapen and grotesque the creature appears.

The Hindus have a type of Cyclops myth as well, though theirs involves a four-armed giant with a third eye in the middle of its forehead, not just one eye altogether. His name was Sisupala and it's said he was the offspring of a human woman and the God Shiva. It was prophesied that his third eye would shrivel when he met the man who would kill him and this is exactly what happened when he met Krishna for the first time. Sisupala's mother begged Krishna not to kill her son, and Krishna relented to a point. In a deal that would seem to be more than fair Krishna agreed to spare the Cyclops' life one hundred times. Krishna was good to his word. The Cyclops walked away unharmed from one hundred encounters with Krishna, but when the one hundred and one occasion came around, Krishna pulled the sun from the sky and used it to kill Sisupala.

Dwarves

Dwarves, though now a universally known creature of the so-called modern mythology, originated in Norse and German mythology. They are mostly identical to a regular human, except that they are shorter, hairier, and have stockier builds. They are usually depicted as men with long beards, wearing rough-hewn tunics or bulky armor. The race of dwarves is extremely protective of their children, since it is so rare for children to be born to this long-lived, but not very prolific race. Many early sources describe dwarves as being an entirely male race, without ever explaining how an all male race manages to procreate and make more dwarves. J.R.R. Tolkien solved the problem neatly by saying that there are, in fact, female dwarves — it's just hard to tell them apart from the men because they are as manly and bearded as their husbands! The folk traditions of Fiji are ones of the only places outside of modern mythology to discuss female dwarves. In Fijian tradition their dwarves, the veli, lived in trees rather than underground and the males were polygamists who left all the work to their wives. The veli, act more like fairies, stealing iron tools from workers, then like hardworking Norse dwarves. The veli, both male and female, also have an unprecedented fondness for wearing their hair in pigtails, a fashion trend uncommon in the European dwarves.

Gnomes and a Small Bird. *By Theresa Kenyon.*

Promised Land. *By Juliet Firstbrook.*

Dwarves live underground, in vast gem en-crusted caverns, and are known for their enormous treasures and unsurpassed mining skills. Dwarves are also wonderful smiths that have forged many legendary magical weapons and near indestructible enchanted armors. Norse mythology says that it was Dwarves who forged the mighty hammer of Thor, Mjolnir.

Dwarves have a reputation for being hard work-ers, though surly and disagreeable, but above and before all else they are practical to the extreme. They concern themselves with the race of men only very rarely, and have little interest in what occurs above ground. Their time is spent mining, tunneling, and blacksmithing; they know little of neither music nor the arts, and nor do they care to learn anything

Black Hole. *By Juliet Firstbrook.*

about these graces. The word gnome has become somewhat interchangeable with the word dwarf, although gnomes are usually the friendlier woodland dwelling cousins of dwarves.

The African version of dwarves is called the wokulo. They stand about three feet high and have oversized heads covered in wild tufts of hair. They can turn invisible at will and have the ability to see through walls and dense trees. They use their invisibility to steal food from humans, and they usually get off scott free if they are somehow caught- despite their small size, they can throw a full grown human adult about fifty yards. In Polish folklore dwarves are called the polewiki, they have wild colored eyes and grass for hair. They dress very uniformly in black, white, or gray and allow no colored clothing or accessories on their person. These are dour little men, even by dwarf standards, and are seen only at dawn and dusk, when they like to check the fields to make sure farmers are working hard. If they catch anyone asleep, or drunk, on the job they beat them severely, and sometimes even trample them to death with their horses.

The nain, of Breton lore, are even more menacing dwarves then the polewiki. They have razor sharp claws on their hands, and hoofed feet.

Giants

Giants are the polar opposites of dwarves. They are also mostly humanoid creatures, but of exceptionally large size. Many cultures say that their size is eclipsed only by their stupidity, and their wanton cruelty. These same sources declare that giants are the eaters of children, the blighters of crops, and the crusher of houses. However, other cultures see giants as being very wise, acquiring much knowledge as they go through their extremely long lives, and that they are really rather friendly.

Midnight Snack. *By Susan Brack.*

Most of mythology tells us a much different story. Finland's giants, the kaevanpojat, are actually a tribe of demons who despise humans and go out of their way to destroy fertile fields and spoil wells. One of their giants in particular, Hiisi, is an overseer of a grove where sacrifices were made in the earliest times. He has lopped sided eyes that lack lids so he stares unceasingly. In the Greek myths, giants are the children of Uranus and Gaia, making them siblings to Cyclops and predecessors to the Gods and Goddesses. They are timeless, chaotic creatures that rallied themselves into an army in an attempt to take the Gods down and end their rule of Olympus. Of course, the hero Hercules defeated the giants, securing the reign of Zeus once again. The Greeks believe that some of the giants remain alive, imprisoned in the Earth as punishment for their part in the uprising. Earthquakes and volcanic eruptions are the fault of the restlessness of these prisoners.

The Greeks saw several variations in their types of giants. The ones who fought against the incumbent Gods and Goddesses of Olympus were the gigantes, but they also had three bothers; Kotto, Briareus, and Gyges, who were hundred handed giants, with fifty heads, that were known collectively as the 'hecatoncheires'. These brothers were instrumental n helping the Gods and Goddesses fight the Titans, also primordial giants, before Zeus came to power. The Greeks also had a giant with a thousand eyes, Argus, that was much treasured as a guardian because even while asleep at least one of his eyes remained open.

Norse mythology follows along the same vein, saying that the giants are in constant struggles with their pantheon of Gods and Goddess. The Norse myths differentiate giants even further, separating them into elemental races. There are many stories of ice giants, fire giants, and, strongest of all, the Earth giants. Even though some stories of Gods and Goddesses marrying and having children with giants exist, and giants are said to be the flesh that man sprung from, giants are also the source that monsters came from. On top of that giants are prophesized to be the ones who will bring about the end of the world, an event known as ragnarok. Ragnarok will come to pass when the giants, and their allies, storm the home of the Gods and bring them down after a mighty war ... and which will spell the end of all of creation.

Butterfly Fright. *By Susan Brack.*

But giants are not just seen as world destroyers; in other cultures giants are the pillars that hold up the world and keep it from falling through space, and in other places there are even stories that the Earth was formed from the body of a fallen giant. The Chinese, who believe that the sky and Earth formed in an egg, also believe that a giant named Pan-Gu hatched from the same egg. The force of his birth created the mountains and, since he grew almost a dozen feet a day from birth onward, his very footsteps changed the layout of the land and seas. His accelerated growth continued until the gigantic Pan-Gu burst apart and died, becoming the universe. His breath became the wind, his voice thunder, and his eyes became the sun and the moon. According to this story we humans formed from the fleas living in his wild hair. Not a very glamorous beginning, to say the least.

The Ethiopian giants, the blemjahs, are especially scary. These massive humans have no heads, and instead their eyes and mouth sit in the middle of their chest. At the opposite end of the spectrum from the blocky headless blemjahs are the very gifted alabaster giants of Russian folklore. The alabasters are no mere clunky oversized humans. One the ground they are shape shifters, even though their usual form is that of a giant with long white hair. In the sky the alabaster turn into comets. As enchanting as old men comets might sound the alabaster should be feared. They form from the souls of dead children and their mission is to punish promiscuity with pain, disease, and sometimes even death. They often trick humans into sleeping with them just to have an excuse to punish them later! Russians place iron crosses at their doorsteps and windows to repel the lustful alabaster but, if the creature manages to get past their defenses, it can be driven away by breaking the little finger on its left hand.

Many countries have strange variations of giants, which while unique, are not too surprising given their locale. In Scandinavian, for instance, they have frost giants while the Egyptian giants have noses like the long snouts of crocodiles.

Goblins

Goblins are among the hardest fantasy creature to classify and describe. Our modern day image of a goblin is a small, twisted, green skinned fellow who causes everything from simple mischief, like hiding items you need, to a magical creature who controls the power of fire at his whim, to even a blood thirsty cannibal. In ancient times goblins were all this, and much, much more. They were seen as everything from ghosts to dwarves, to users of magic, to stealers of babies and young virgins, wise, stupid, cruel, helpful around the house and farm, and even invisible to the naked eye.

Goblins are nomadic creatures, hitching rides wherever they can, and living under rocks, in small damp caves, or under the roots of trees. Sometimes, like dwarves, they are said to be an entirely male race. Scotland was troubled by a nasty race of goblins called the hobbyah that kidnapped and ate people, though children were their favorite snack. In Korea they are called the tokebi.

54a. By Jamila Houde.

109

Golem

The word golem means, simply, lump or material; in the Bible the term refers to an unfinished substance. A golem is a creature, shaped crudely like a man, from dirt or mud and given life by a holy person. This usually involves placing a clay tablet beneath their tongue and inscribing the word 'life' or 'truth' on their foreheads. The reason these words are used to give them life is because, in Hebrew, erasing just one letter from them turns the word into 'death', thus giving an easy way of killing or deactivating the golem when his usefulness is done.

The golem is often made to be the size of a small giant because they are used as servants or protectors. Unfortunately the golem possesses life, in a crude form, and strength — not intelligence. Things sometimes go terribly wrong if a golem is given a command and left unsupervised because it will carry the task out as literally as possible no matter what happens. In some Jewish tales the creature is almost a Frankenstein monster, it can turn on its creator and kill them. Another important aspect of the golem is that it lacks the ability to speak. It is felt that if such a creature could speak then it must contain a soul, which could be very dangerous since the golem, created by man and not God, can never be made perfectly.

Golems are best known to us from Jewish mythology, although the creature does not seem to be original to them, our modern idea of the golem is exact to the version the Jews popularized in the sixteenth century.

Of course, while the golem may be mostly well known as a creature from Jewish mythology, golem like creatures crop up in different forms worldwide. For instance, in Finland shamans can create men of Earth, called a stallo, by sculpting a man's shape from any land that never before has been touched by a human's feet or hands. The shaman then very slowly breathes over the creature and declares that he shares his strength, and years from his life, with the stallo. At this point the stallo comes to life and serves his master. Most often this involves visiting (which is what the word stallo means) a neighboring shaman and causing as much mischief and trouble as the stallo can get away with at that shaman's household. The stallos often challenge the rival shaman to a battle to the death. If the stallo wins then his creating shaman takes his rival's land, magical items, and clients. If the besieged shaman bests the stallo most often the creating shaman will die since he immediately loses his strength and the years he has granted the stallo.

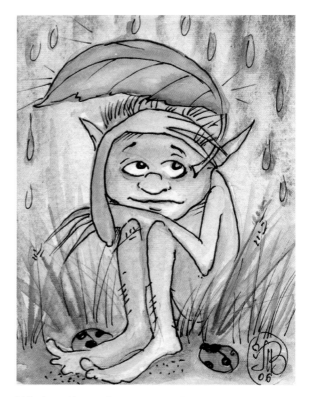

Why's it Always Raining on Me?
By Maria Van Bruggen-Elfies.

Gremlins

Believe it or not gremlins are the youngest of our fantasy creatures, since the term was coined as recently as World War II! During the war, when mechanical devices failed or planes crashed for no reason, military personnel chalked it up to the antics of these devious little creatures. The name gremlin is a bastardization of the Old English word 'gremian' that means, simply, to vex.

The idea of gremlins took hold after the war was finished and, with the advent of our wondrous and wondrously frustrating computer age, the idea of gremlins is here to stay. Anytime your car won't start, or your laptop crashes, rest assured that you are being plagued by gremlins.

Gremlins are usually small, pointy eared, green goblins with long tapering fingers just perfect for reaching inside of electrical devices and causing havoc. They stand at a foot tall, or less, and sometimes are seen dressed in all green. They live in underground boroughs, like rats, under airfields and used car lots.

Gremlins seem to be the modern day equivalent of boggarts, bothersome brownie type creatures that, instead of helping a household, wrecked it instead.

Knackers

Every place that has ever depended on mining has some version if the knackers. They are called knackers, knockers, tommyknockers, kobold, karzalek, sprigguns or buccas depending on where the story comes from. The knockers are tricksters and miners themselves. They are grizzled little old men, almost like a cross between an imp and a dwarf, and live completely underground. They are usually seen dressed in a miner's uniform, though barefoot, and without a light.

Knackers can be anything from mischievous little imps who steal tools and cause other minor annoyances or they can be demons who purposely lead minors astray, killing them. Their most notable habit, which they are known for whether they have good spirits or bad, is their distinctive knocking on the walls of mine shafts just before the tunnel collapses.

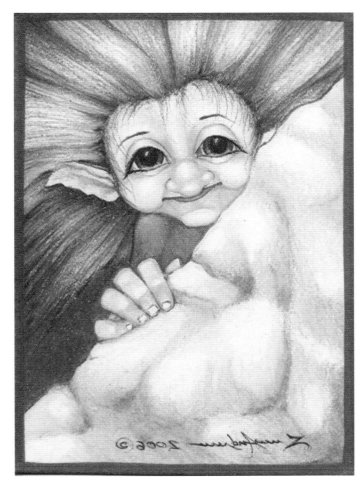

Zayt' al-Zaj. *By Susy Andrews.*

In some countries it is believed that the knackers bang on the tunnels to warn miners of the eminent collapse, giving them time to escape. In other places it is said that the banging is the sound of the knockers themselves causing the cave in.

Even so evidence of knackers is always been taken as a good sign by miners. It usually means there is a plentiful strain of ore nearby.

Ogres

If goblins can be seen as dark and twisted dwarves, then ogres can be seen as dark and twisted giants. And most texts don't show giants as very nice to begin with! An ogre is generally a lumpy, big bellied, vaguely human creature of enormous size. They are dirty and reclusive, stealers, and devourers, of young children.

They take up residence in damp caves, or old and abandoned castle keeps and dungeons. They have veracious appetites and will eat any meaty thing that wanders their way. Ogres are not seen as the best of housekeepers; stories describe them living among the bones and rot of their last few years' worth of meals! An ogre's favorite weapon of choice is a large club, or knotted tree branch, that he can whack potential food over the head with.

The female of the ogre species is called the ogress, and it is quite rare to come across one. Japan has a particularly fierce child-killing ogress named Kojin, who has thousands of arms that she uses to catch and crush her victims with.

Trees

Wait a minute!? You're probably thinking, does that say *trees*? How are trees a mythological creature? Well, trees are an important part of every culture's mythology, and appear in a variety of forms. They ended up here with the Earthmovers because they are of the Earth and because so many cultures believed in the idea of a 'world tree'. If the world tree ever came down it would do a lot more than merely give the Earth a shake.

Yggdrasil, from Norse mythology is probably the most famous of the world trees. In Norse legends Yggdrasil runs like an axis through the center of the Earth. Its roots are planted in the underworld and its branches reach up into the heavens. In world tree myths

the tree holds up the Earth and Heaven, as well as giving or spreading nurturing life. A threat to the world tree is a threat to the existence of all of creation. In the case of Yggdrasil there is a mighty dragon that gnaws constantly at the root of the tree. The world tree was a common motif in medieval Greek folklore, though absent from classical Greek mythology: the world tree is under attack from goblinesque creatures that try to cut the roots of the world tree to bring down the Earth and sky.

Another staple in mythology is that of the talking tree. Talking trees appear in everything from *The Wizard of Oz*, throwing apples at Dorothy for daring to pick fruit off of them, to the wise, slow talking, tree shepherding Ents of J.R.R. Tolkien's *Middle Earth* stories. But, of course, talking, and sometimes walking, trees aren't just a modern invention.

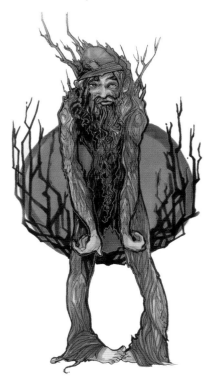

Tall Man. *By Molly Zirofax Rodman.*

India has a magical Tree of the Sun and the Moon. Both Marco Polo and Alexander the Great sought it out, because of the legends of its ability to prophesy the future. Two voices speak from the tree. If you ask it a question during the day it answers as a man; if you talk to it at night the voice replying is female. The Tree of the Sun and the Moon is guarded by massive fire-spitting birds.

Wise Trees. *By Cindy Petersen.*

Titans

The Titans are the mightiest of our Earthmovers, and rank among the mightiest of all the mythological creatures. In classical mythology the Titans were the six sons, and six daughters, of Uranus and Gaia. That, of course, makes them siblings to the Cyclops and giants of Greek myth. The Titans have several attributes of their siblings — they are creatures of enormous size and even bigger strength.

In one story the hecatoncheires, hundred handed giants, were banished by Uranus and sent back into the womb of their mother, the Earth. This upset Gaia so much that she urged the Titans to destroy Uranus and place one of their own as ruler of the Gods. The Titans accomplished this, though later they would help Zeus take down the brother, Chronos, they had placed on the throne. Later Zeus himself would come under attack from the fickle Titans. He, however, was able to defeat them and banished all save one to the underworld.

Sasquatch

Now the sasquatch, also known as the yeren (China), Bigfoot (United States), yeti (Himalayas), yowie (Australia), skunk ape (Florida) and the abominable snowman (India and Canada) may seem like an odd entry into our gathering of creatures of myth and lore. Bigfoot is well known fodder for the tabloid press, and the type of hour long inflammatory 'documentaries' that even usually scientifically sound networks like Discovery or the History Channel air around Halloween time. But when looking through old stories it becomes apparent that Bigfoot has been talked about all throughout history, in many different cultures, and is well deserving of its place here among the more esteemed animals like unicorns and phoenixes.

The sasquatch is a strange cross between human and animal. It is exceptionally tall and walks upright like a man, with long arms dangling down almost like a gorilla. He is covered in coarse stinking tangled hair. As Bigfoot, usually reported in the Pacific northwest of the United States, the creature is chocolate brown. When seen as a yeti up north, it is normally white or grey, though some people have seen it as a mottled brown white color leading to speculation that the sasquatch changes colors with the season. Despite its large size, and possible incredible strength, the sasquatch is reclusive and shy, especially among humans. They are usually seen as solitary creatures, residing in the deepest woods, although there are some stories of female sasquatches, and sasquatch young.

The sasquatch has been reported, and in some cases even recorded and photographed, enough times that many people believe it is an extremely rare but all too real creature. There is a subset of the scientific community that studies the possibility of such things called cryptozoololgy.

Bigfoot, or sasquatches, are nothing new to this era. In medieval Europe they believed in an identical creature called the woodwose, though they made the creature out to be more man like, than apelike, and much less reclusive. The image of a woodwose even appeared minted on coins in the seventeenth century.

In Guatemalan folklore, and some of the stories seem to derive from even further back when Guatemala was under the rule of the grand Mayan empire, they talk about the chorti, who looked like the reclusive sasquatch but had the temper and intelligence of a particularly cruel and stupid giant. This beastly man had feet that faced backwards and ended in razor sharp metal claws. Throughout Mexico there are several similar creatures, the Yaqui in particular seem to have had an exceptional fear of the creature.

The sasquatch of Russian lore, the ovda, is very clearly in the realm of fantasy rather than cryptozoology. Like its Guatemalan cousin it had backwards facing feet, but unlike your average sasquatch the ovda purposely seeks out travelers and its laughter can be heard ringing through the forest. But the ovda is not as good-natured as this might make him seem. When he comes across travelers he tickles them to death and will ride their horses until they drop dead from exhaustion.

The almas are a Mongolian version of the sasquatch, though they are said to be closer to being simply wild people than being ape like. The sightings of almas sound almost like remnants of early humans, Neanderthals perhaps, with the sloped shoulders and prominent brow ridge above the eyes. Further mudding the line between fact and fiction almas are depicted in old, but not ancient, medical texts as living humans. There is even a bizarre story of a captive alma dating back from the mid 1800s. This woman was captured and named Zana. It took several years, but her human keepers eventually taught her the simple menial jobs of a low level household servant. Even more bizarre Zana gave birth to several children over the years, children that

had a human father. Most of the offspring did not live through infancy, but four did survive. The two boys and two girls were doled out to neighbors to raise and all four went on to pass as fully human and have typical human lives. All four even had perfectly normal human babies later in life! So many people think that almas may just be people who choose to hide in the Siberian wilderness, due to malformations that makes them appear less than human, and some people think that they may be a left over cache of pre-humans that have somehow survived to this day. As with many of our mythological creatures there is possibly a grain, or several grains, of truth behind the stories.

Trolls

Troll is another word that can mean many different things to many different people. In some cultures they are similar to goblins, in others they are more like hairy monstrous giants. The word itself, in the old Norse, simply means monster and can be applied to any black-hearted thing that crawls up from the bowels of the Earth. They can be seen as being any size from slightly bigger than a human to larger than the biggest giant. The troll is usually green skinned, always ugly, and never without its foul temper. Trolls, most often in Scotland where they are called henkies, walk with a slight limp, dragging their foot, and sometimes have a hunched back. Trolls generally live in caves, under bridges, or deep under ground. Oftentimes they live with a pile of treasure they horde for no reason that anyone can tell.

Trolls despise humans almost as much as they hate noise and are solitary creatures. They sometimes steal women or children, presumably for food, since the troll will eat just about anything. In some stories, particularly stories from Medieval Europe, it is said that trolls turn to stone of touched by the light of the sun.

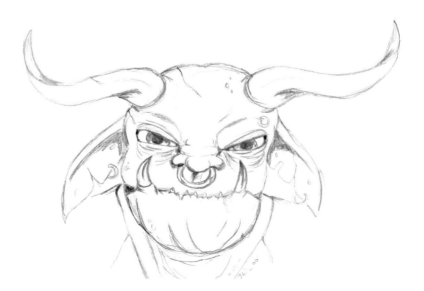

Troll. *By Nina Bolen.*

Gallery

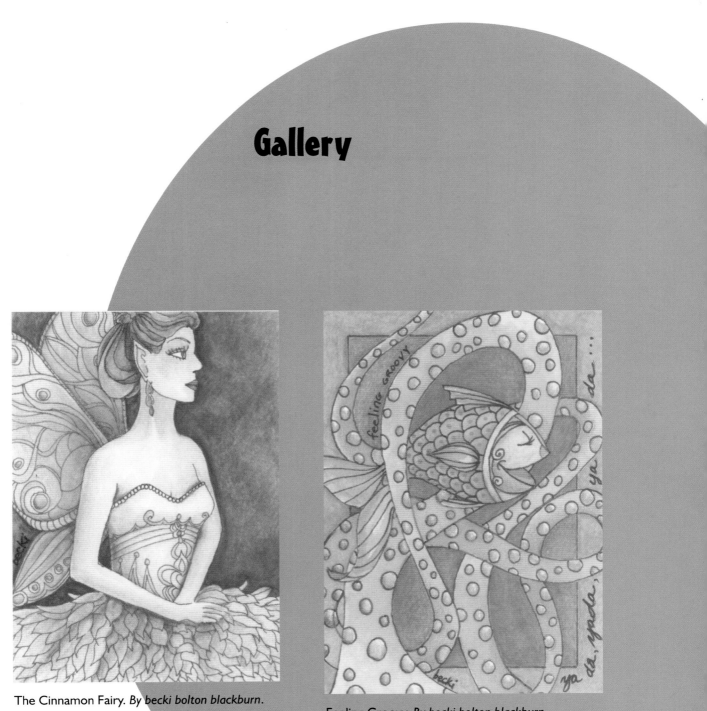

The Cinnamon Fairy. *By becki bolton blackburn.*

Feeling Groovy. *By becki bolton blackburn.*

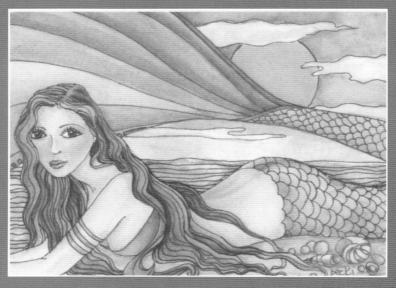

Emerald. *By becki bolton blackburn*.

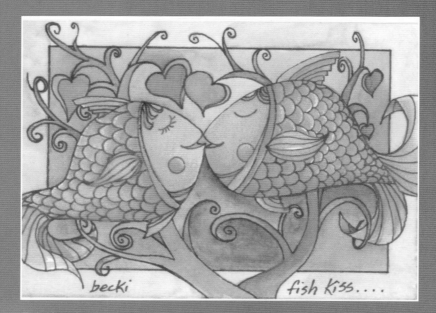

Fish Kiss. *By becki bolton blackburn*.

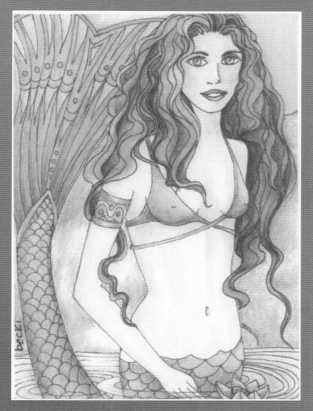

Irish. *By becki bolton blackburn.*

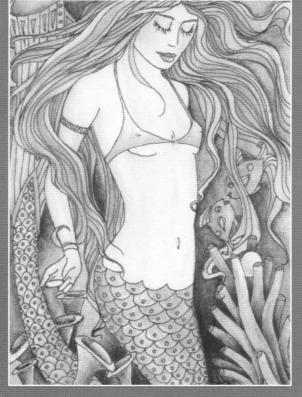

Serenity. *By becki bolton blackburn.*

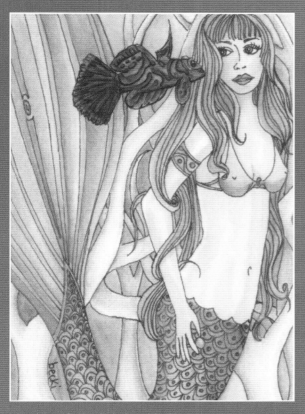

Mandarin. *By becki bolton blackburn.*

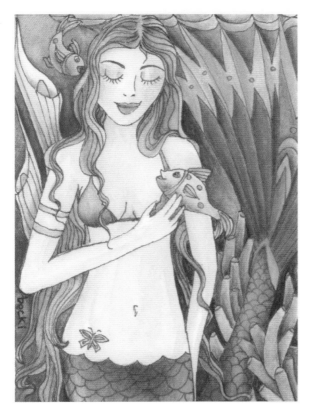

My Friends. *By becki bolton blackburn.*

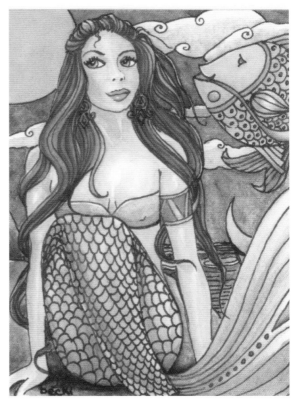

Sweet Secrets. *By becki bolton blackburn.*

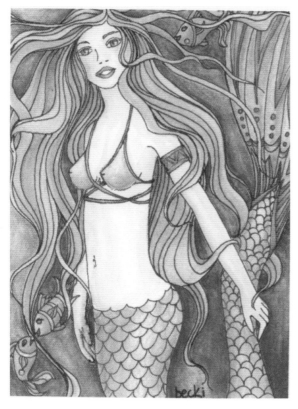

Siren of the Sea. *By becki bolton blackburn.*

Dolphin Fae. *By Elizabeth Wolff.*

Dragon Fae.
By Elizabeth Wolff.

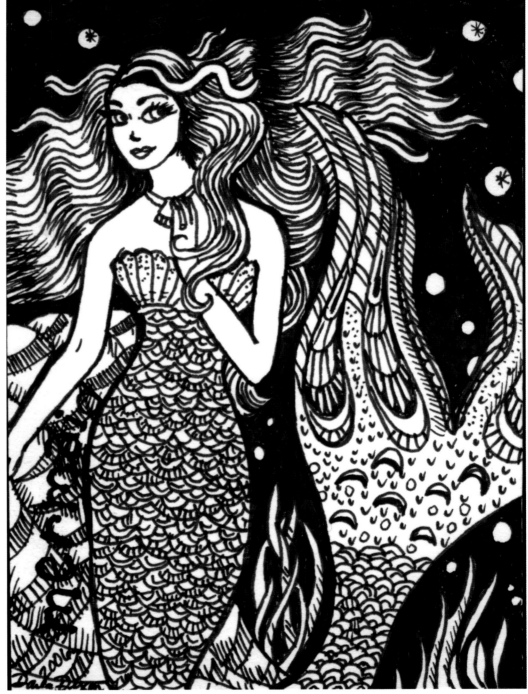

Mermaid. *By Darla Dixon.*

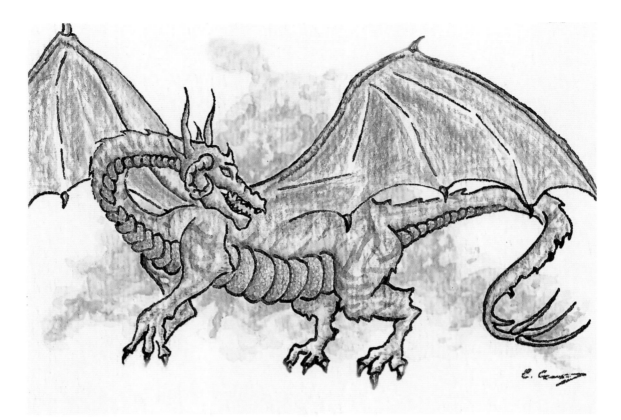

Dragon of the Mist. *By Elizabeth D. Cummings Johnson.*

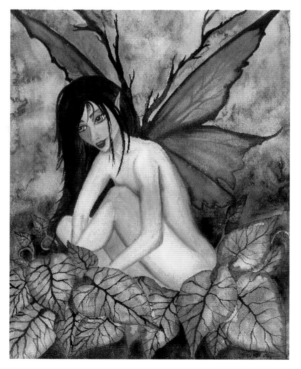

Amber. *By Heidi M. Drake.*

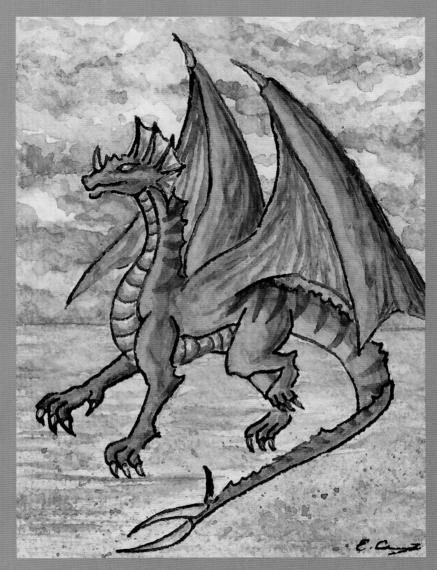

Red Dragon. *By Elizabeth D. Cummings Johnson.*

Beautiful Dreamer.
By Heidi M. Drake.

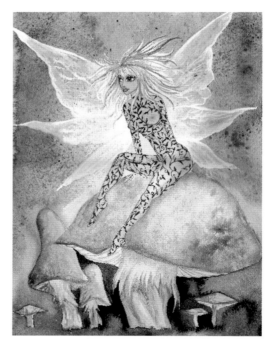

Mushroom Fairy. *By Heidi M. Drake.*

Golden Witch.
By Heidi M. Drake.

Gothic Witch.
By Heidi M. Drake.

Open Doorway. *By Heidi M. Drake.*

Mermaid.
By Heidi M. Drake.

Divination. *By Maria Van Bruggen-Elfies.*

Furry Brave Sailor Pirate.
By Maria Van Bruggen-Elfies.

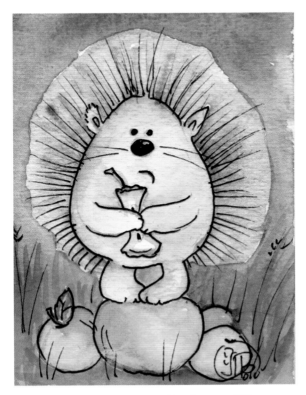

Fast Ending Apple. *By Maria Van Bruggen-Elfies.*

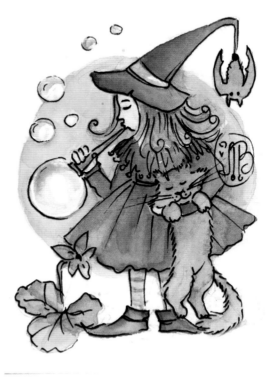

Today is so Bubbly. *By Maria Van Bruggen-Elfies.*

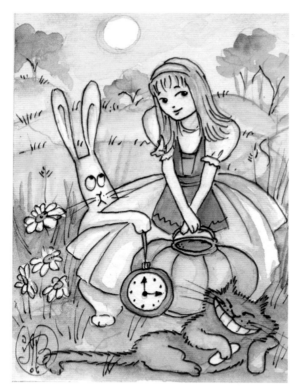

What if? *By Maria Van Bruggen-Elfies.*

Fairy in the Flowers.
By Maureen Craver.

Rhythm. *By Michele Lynch.*

Arachne.
By Michele Lynch.

Witchcraft 911. *By Maria Van Bruggen-Elfies.*

Mermaid in Love. *By Michele Lynch.*

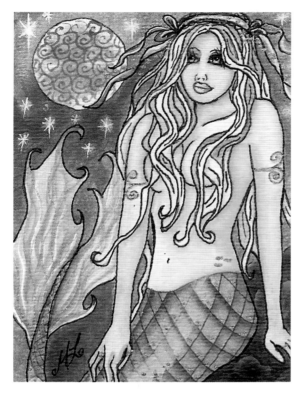

Wishing Upon a Star. *By Michele Lynch*.

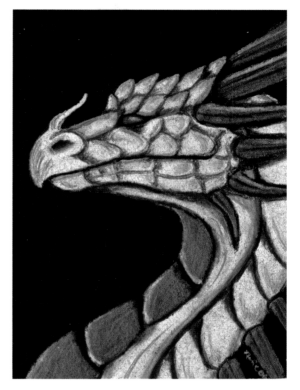

White Dragon. *By Nina Bolen*.

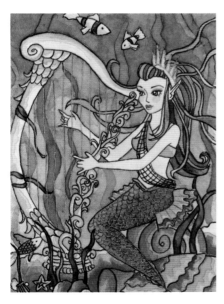

Genna. *By Nikki Burnette*.

Red Dragon. *By Nina Bolen*.

Angel Mermaid. *By Renee Lavoie.*

Lilac Fair. *By Stephanie D. Fizer.*

Mermaid Doll. *By Renee Lavoie.*

Purple Fairy. *By Theresa Kenyon.*

Gabriel the Elf. *By Tiana Fair.*

The Fairy Queen. *By Tiana Fair.*

Pixie of the Lake. *By Tiana Fair.*

Autumn. *By Juliet Firstbrook.*

Bronze Cave. *By Juliet Firstbrook.*

Cool Blue. *By Juliet Firstbrook.*

Coral. *By Juliet Firstbrook.*

Freedom Flight. *By Juliet Firstbrook.*

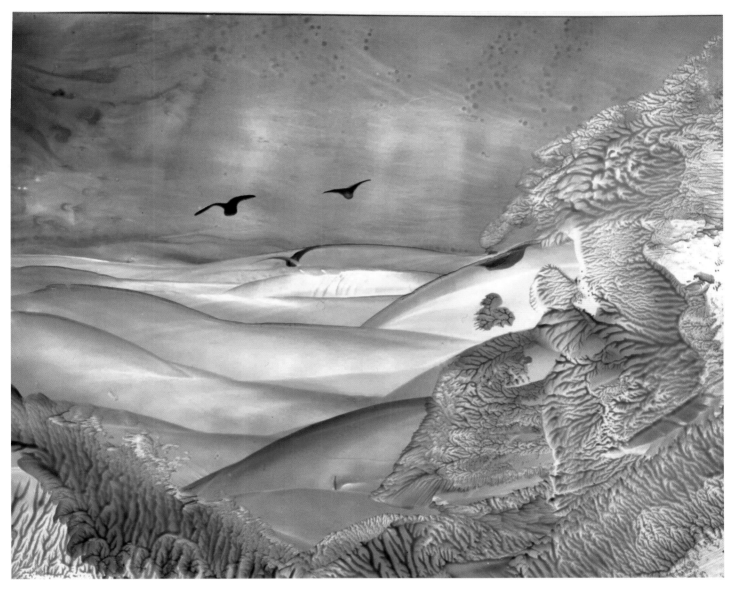

Jade Land. *By Juliet Firstbrook.*

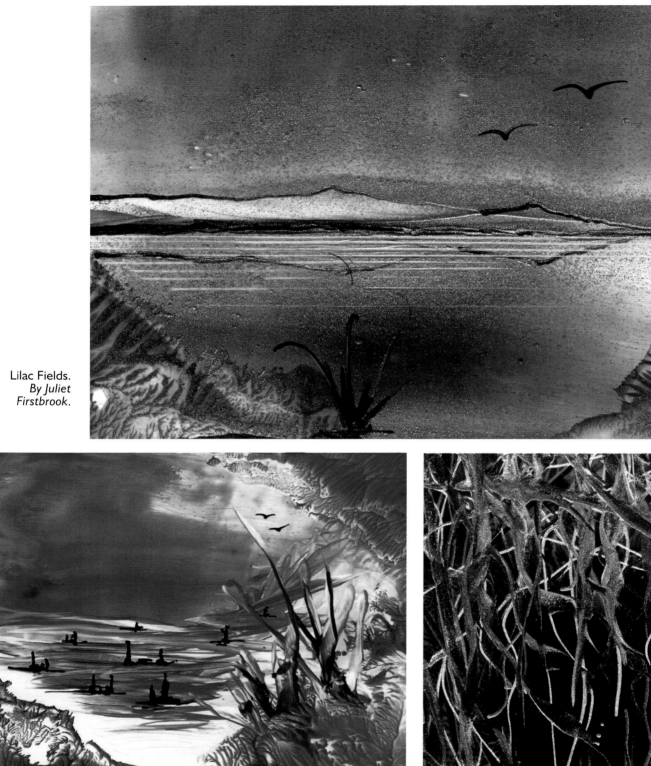

Lilac Fields.
By Juliet Firstbrook.

Petrified Forest. *By Juliet Firstbrook.*

Mercury Cave.
By Juliet Firstbrook.

Rainbow. *By Juliet Firstbrook.*

Tropical. *By Juliet Firstbrook.*

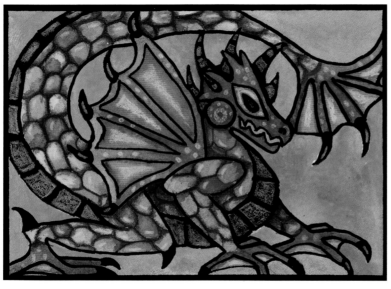

Azul. *By Cara Brown.*

Glory of the Morning. *By Cara Brown.*

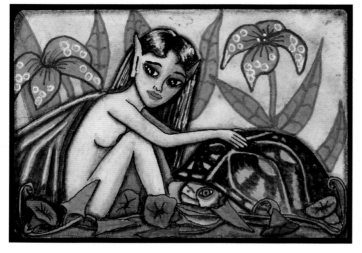

Troll Baby. *By Cara Brown.*

Rakia Elfin Princess.
By Cara Brown.

Head Sound. *By Olga Ziskin.*

Red Beads. *By Olga Ziskin.*

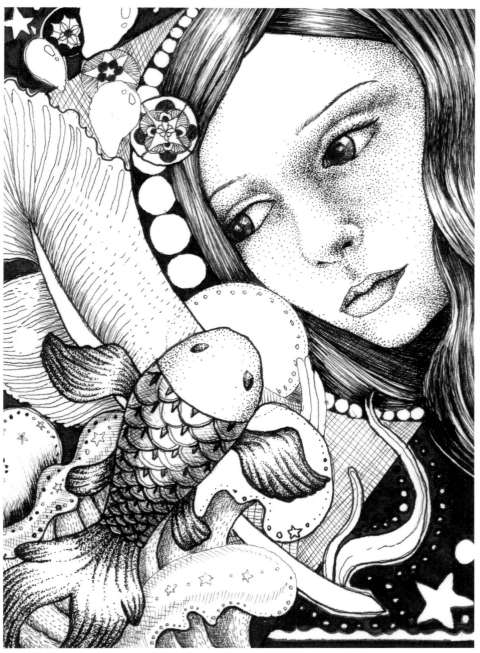

All We Need is a Feather. *By Olga Ziskin.*

The Last of Summer.
By Olga Ziskin.

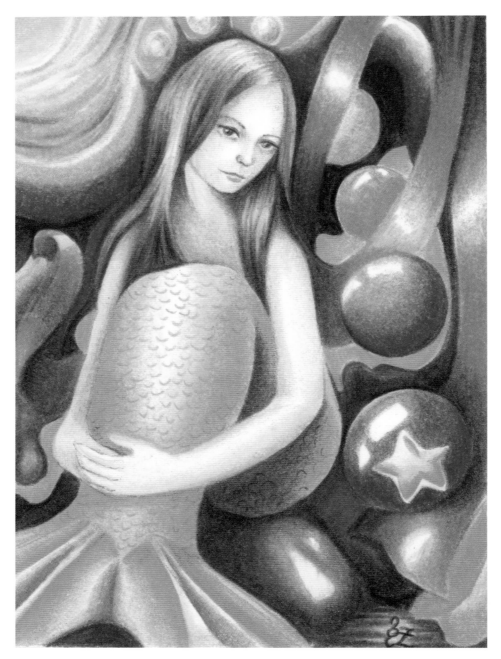

Daydream. *By Olga Ziskin.*

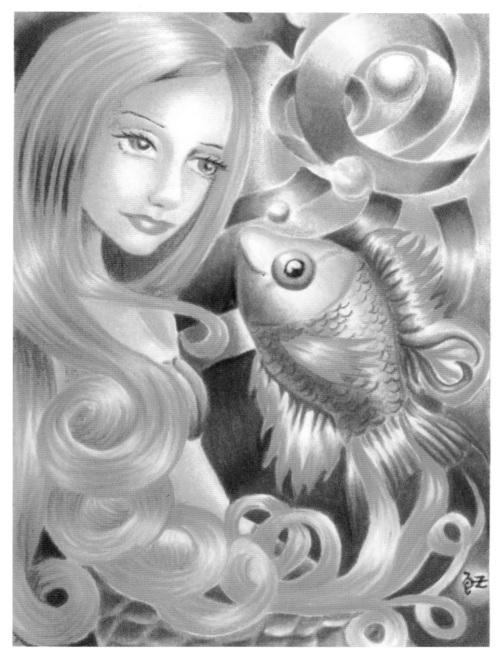

Rainbow Fish. *By Olga Ziskin.*

Afraid of Heights.
By Misti Hope Wudtke.

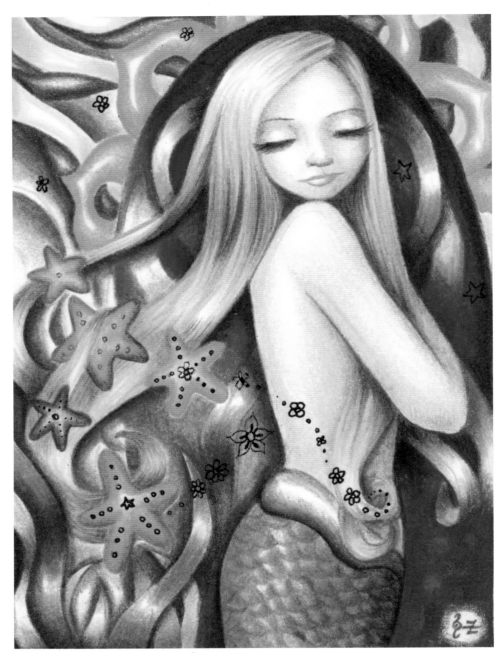

Sea Stars. *By Olga Ziskin.*

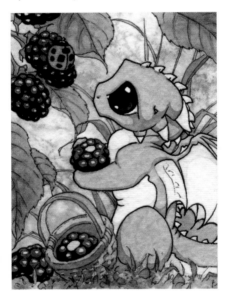

Blackberries.
By Misti Hope Wudtke.

Bookwyrm. *By Misti
Hope Wudtke.*

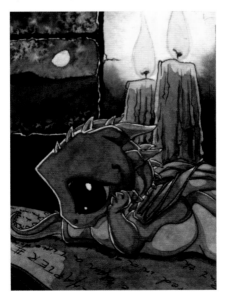

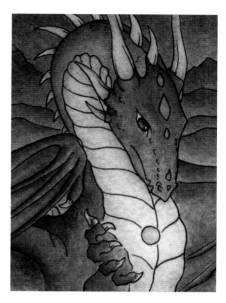

Catch a Falling Star.
By Misti Hope Wudtke.

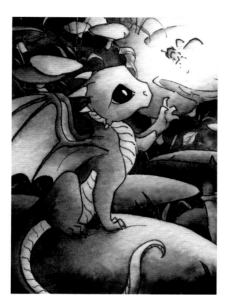

Firefly. *By Misti Hope Wudtke.*

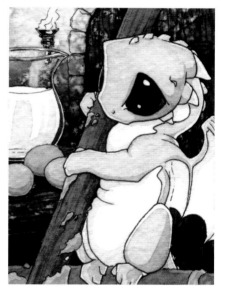

Cookie Dough. *By Misti Hope Wudtke.*

Goofy Dragon. *By Misti Hope Wudtke.*

Far From Home. *By Misti Hope Wudtke.*

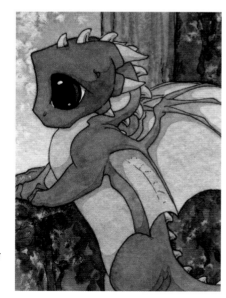

Homecoming. *By Misti Hope Wudtke.*

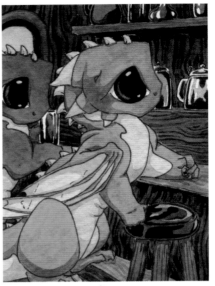

In Taberna. *By Misti Hope Wudtke.*

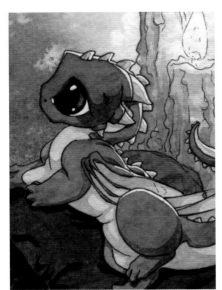

Lawrence. *By Misti Hope Wudtke.*

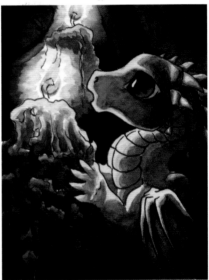

Keeper of the Flame. *By Misti Hope Wudtke.*

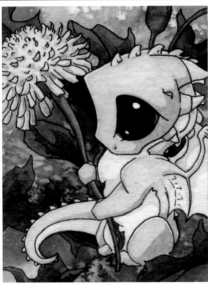

Lions Tooth. *By Misti Hope Wudtke.*

Kitten Hug. *By Misti Hope Wudtke.*

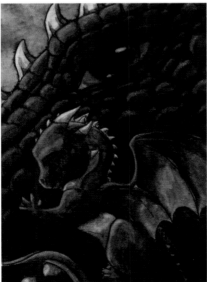

Mama. *By Misti Hope Wudtke.*

My Pile. *By Misti Hope Wudtke.*

Snow Business. *By Misti Hope Wudtke.*

Red Dragon. *By Misti Hope Wudtke.*

Spibbles. *By Misti Hope Wudtke.*

Sir Everett. *By Misti Hope Wudtke.*

Starry. *By Misti Hope Wudtke.*

Sunset Silhouette. *By Misti Hope Wudtke.*

Lady Evelyn. *By Misti Hope Wudtke.*

Elderberries. *By Misti Hope Wudtke.*

Letter to Santa. *By Misti Hope Wudtke.*

Finger Painting. *By Misti Hope Wudtke.*

Lost. *By Misti Hope Wudtke.*

May I go Flying? *By Misti Hope Wudtke.*

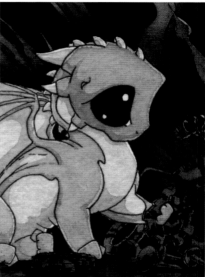

Oops. *By Misti Hope Wudtke.*

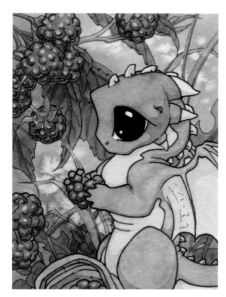

Raspberries. *By Misti Hope Wudtke.*

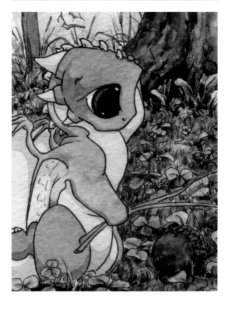

Plunk. *By Misti Hope Wudtke.*

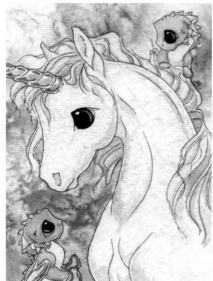

Ribbons. *By Misti Hope Wudtke.*

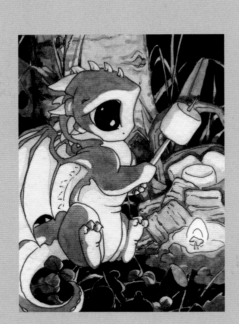

Smores. *By Misti Hope Wudtke*.

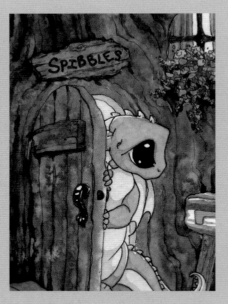

Someone. *By Misti Hope Wudtke*.

Artists

"Fantasy, abandoned by reason, produces impossible monsters; united with it, she is the mother of the arts and the origins of marvels."
Francisco Goya

This book wouldn't exist without the enormous talent of the artists who were kind enough to share their work. Below you will find a list of contributors to *Fairies, Mermaids, and Other Mystical Creatures*, and their contact information. They are the sole owners, and creators, of the work credited to them and this book would not exist without their generosity in sharing the creations.

The work shown runs the gamut from traditional watercolor paintings and pen and ink illustrations to more unusual mediums for the ACEO genre, like stained glass and textile art. The artists involved, and their styles, are as diverse as the creatures talked about in the book.

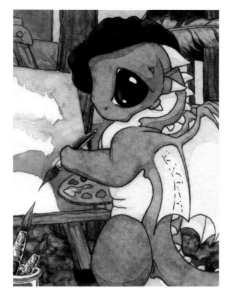

Bartholomew. *By Misti Hope Wudtke.*

Janette: JGbard@Yahoo.com

Susy Andrews: Suantova.com

Ronne P. Barton: Ronne@Webworkz.com or RonneBarton.com

Becki Bolton Blackburn: She can be found on both eBay.com, member I.D Art By Becki, and on EBSQ.com

Lorelei Bleil: www.Forest-Dreams.com or Lilac. Angel@gmail.com

Nina Bolen: enchantmentsart@hotmail.com

Susan Brack: SusanBrack.com

Brittany M. Brewster: BMWFoxy@Yahoo.com. To see more of her work, go to eBay.com, user I.D Morganvega

Cara and Christi Brown: C and C Fantasy Art, 1332 15th Street, St. Los Osos, California 93402, or visit this artist on the web at www.CandCFantasy Art. com. Their email is CandC@CandCFantasyArt. com.

Nikki Burnette: Aurella-art.com or Nicole-Burnet@Yahoo.com

AGCOOK: Jarniganc@Yahoo.com

Teresa Coville: Visit her online at eBay.com stained glass store: The Sisters Stained Glass.

Denise Connell: aliceart259@yahoo.co.uk or aliceart.etsy.com

Maureen Craver: MaureenCraver@Yahoo.com

Elizabeth D. Cummings Johnson: ArtsyFartzy@Gmail.com or Myspace.com/ArtsyFartzy

Darla Dixon: www.pencil-portrait-drawing-artist.com

Heidi M. Drake: Iwaniukh@aol.com

Jamie Fales: NoosedKitty.com or Jamie@NoosedKitty.com

Tiana Fair: www.TianaFair.com

Sonya Fedotowsky: ForestElf.com

David Ferreira: Phone: (978) 317-5253 or e-mail: DFerreira@Comcast.net

Juliet Firstbrook: JulietFirstbrook@Hotmail.com

Stephanie D. Fizer: Fizerfaeryart.etsy.com or sfizer@gmail.com

Starla Olevia Friend: dragonstarart.com or Starla@dragonstarart.com

Krystal Garrison: www.KrystalGarrison.com (took author's photo)

Jamila Houde: Atomikheart.deviantart.com or Myspace.com/grumpyshampoo

Roselle Kaes: RoselleKaes.com

Theresa Kenyon: vtsi_tiger@yahoo.com; to see more of her work, go to eBay, member I.D Theresa7289

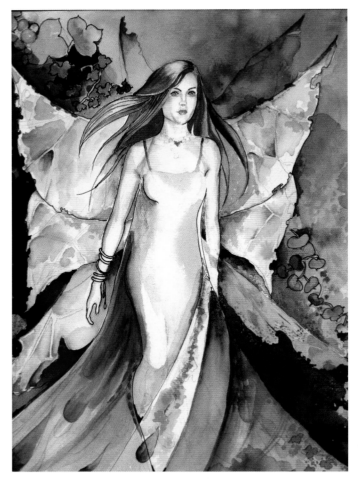

Metamorphosis. *By Denise Connell.*

Fairy Mage. *By Denise Lopez Ramirez.*

Celtic Maiden.
By Denise Connell.

Autumn dancer. *By Heidi M. Drake.*

Leah. *By Nikki Burnette.*

Kris J. Kormish: Box 88 Rochfort Bridge Alberta, TOE IYO Canada, eBay member I.D. 000StarvingArtist000

Ching-Chou Kuik: chingchoukuik@gmail.com

Renee Landry Lavoie: www.designsbyerenee.com

Michele Lynch: MicheleLynchart.com

Kerry Nelson: EquiArtnMore.com

Cris Nichols: CrisNichols@Yahoo.com

Rochelle Angelique Ortiz, A.K.A. Teardrop: Rochelle_Ortiz@Hotmail.com

Cindy Petersen: Visit her online at eBay.com stained glass store: The Sisters Stained Glass

Denise Lopez Ramirez: P.O. Box 67262, Charlotte, North Carolina 28226 or email Denise RamirezLopezArt@yahoo.com.

Michael Ramirez: Muggins@msn.com

Molly Zirofax Rodman: Zirofax@Hotmail.com

Maria Van Bruggen/Elfies: info@elfies-world.com or Elfies-World.com

Elizabeth Wolff: AngelVisionary.com

Misti Hope Wudtke: Mhw@misitique.com or Mistique.com

Olga Ziskin: Oziskin.com

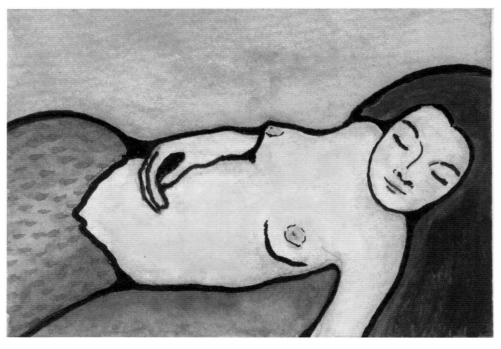

Sleeping mermaid. *By Maureen Craven.*

Pandora. *By Janette.*

Chases the Blues Away. *By Susy Andrews.*

Inanna. *By Janette.*

Bibliography

Bulfinch, Thomas. *Bulfinch's Mythology*. New York, New York: Modern Library, 1998.

Campbell, Gorden Lindsay. *Strange Creatures: Anthropology in Antiquity*. London, England: Gerald Duckworth and Company, 2006.

Campbell, Joseph. *The Masks of God Volume One: Primitive Mythology*. New York, New York: Penguin Books, 1991.
The Masks of God Volume Two: Oriental Mythology. New York, New York: Penguin Books, 1991.
The Masks of God Volume Three: Occidental Mythology. New York, New York. Penguin Books, 1991.

Davidson, Avram. *Adventures in Unhistory: Conjectures on the Factual Foundations of Several Ancient Legends*. New York, New York: TOR Books, 2006.

Grant, Michael and Hazel, John. *Who's Who in Classical Mythology*. New York, New York: Oxford University Press, 1973.

Hamilton, Edith. *Mythology*. Boston, Massachuesettes: Bay Back Books, 1998.

Mack, Carol and Dinah. *A Field Guide to Demons, Fairies, Fallen Angels and Other Subversive Spirits*. New York, New York: Owl Books, 1999

Matthews, Caitlin and John. *The Element Encyclopedia of Magical Creatures*. New York, New York: Barnes and Noble, 2005.

Nigg, Joe. *Wonder Beasts: Tales and Lore of the Phoenix, the Griffen, the Unicorn, and the Dragon*. Westport, Conneticut: Libaries Unlimited, 1995.

Rose, Carol. *Giants, Monsters, and Dragons: An Encyclopedia of Folklore, Legend, and Myth*. New York, New York: W.W. Norton and Company, 2001.

Rose, Carol. *Spirits, Fairies, Leprechauns, and Goblins: An Encyclopedia*. New York, New York: W.W. Norton and Company, 1998.

"Strange Stories, Amazing Facts." *Readers Digest*. Readers Digest Association Far East, 1977

Strassburg, Richard. *A Chinese Bestiary: Strange Creatures from the Guideways Through Mountains and Seas*. Berkeley, California: University of California Press, 2002.

Web sites:

Bonni.net
Draconian.com
Dragon-Warrior.com
Eaudrey.com
FaeryTrail.com
GodChecker.com
Infoplease.com
JewishEncyclopedia.com
Myth_and_Fantasy.com
Occultopedia.com
Pantheon.org
RwaNational.org
ScifiCrowsNest.com
TheSereneDragon.net
Timelessmyths.com
WhiteRosesGarden.com
Wikipedia.org

Index